STiCKeR CiTy

Claudia Walde

STiCKeR CiTY

Paper Graffiti Art

with 317 illustrations, 308 in color

Thames & Hudson

First published in 2007 in paperback in the
United States of America by Thames & Hudson Inc.,
500 Fifth Avenue, New York, New York 10110

thamesandhudsonusa.com

Library of Congress Catalog Card Number
2006908839

ISBN-13: 978-0-500-28668-5
ISBN-10: 0-500-28668-X

Printed and bound in China by
SNP Leefung Printers Ltd

Contents

Shepard Fairey, Chicago

Introduction

For some forty years city streets have been home to the modern graffiti movement, but the new century has witnessed a fresh creative explosion. Walls, phone booths, guttering, traffic signage —the full range of surfaces that make up the astonishingly vibrant street canvas is now adorned with hand-painted or crafted stickers and posters. This form of adhesive art, a subset of the booming street art scene, has mushroomed so much that stickers and posters have become even more widespread than classic graffiti in some areas.

So why has adhesive art experienced such a meteoric rise over the past few years? Answering this question is just as much an aim of this book as the lively presentation of a thriving subculture. Though the reasons are by no means clear-cut, timing seems to have been a vital element. Young people, schooled by the graffiti movement, view the urban sprawl as their space, but the penalties for getting caught with a spraycan in your hand have become increasingly severe. Stickers and posters provide a fresh artistic outlet: not only can they be dispersed quickly, but artists can hit far more spots at any one time. Technological advances over the past few years have also played a part, particularly in terms of travel and home computers: nowadays, it is easy to create stickers and posters in the comfort of your own home, at a relatively low cost, and hop on a plane from one city to the next; while the Internet has enabled like-minded individuals around the globe to pool ideas and access the latest trends.

Though adhesive art has been my primary focus, I have sometimes needed to cross over into other relevant subsets of both street art and graffiti, where the borders are often blurred. It would be impossible to cover every aspect of such a vast and changeable scene in one title; this book details a cross-section of techniques and artists, from pioneers such as Swoon, Shepard Fairey and Invader to up-and-coming stars. It is through the ingenuity of such figures that adhesive art has shown its true potential. And in such a rapidly evolving scene, it will be exciting to see what the future holds.

Chapter One

A Sticky Start

Over the past few years the popularity of adhesive art has rocketed among contemporary urban artists, but plastering stickers or posters around city streets is by no means a new phenomenon. This medium's rich history in urban art stretches back to the 1950s and is intertwined with the growth of the advertising industry, which has always relied so heavily on the ideas of freethinking artists for innovative artistic approaches. Since then, the poster has grown to become one of the largest sectors of mass media, a hugely significant vehicle through which companies can communicate with the general public. Countless urban artists have cited the fight against ubiquitous consumer manipulation as their primary motivation for choosing to work so publicly in the streets. ➡

Bäst, New York City

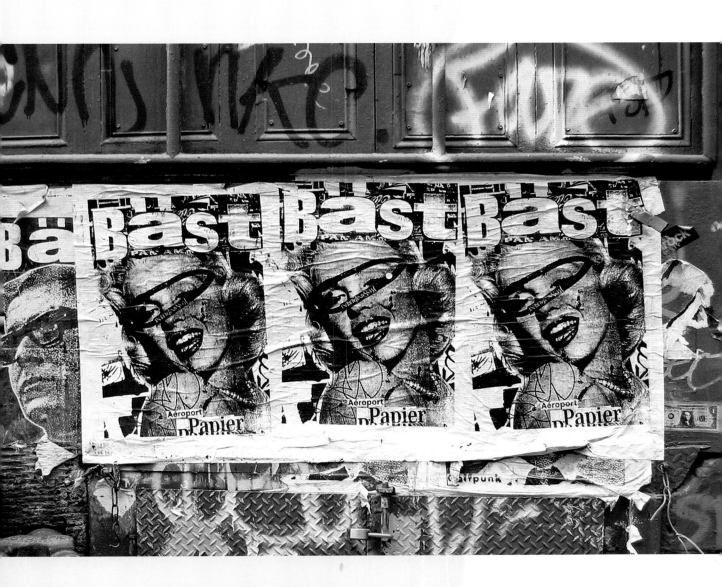

Our society is changing all the time, and no artistic medium reflects this fast pace of life better than the poster. It has been used to grab people's attention for hundreds of years; contemporary advertising is just the latest in a long line to pursue this objective. Our present-day understanding of the poster is primarily connected with paper, although wall inscriptions were used to promote professional battles and events as far back as ancient Pompeii.

The word 'paper' comes from papyrus, which was produced in Egypt from around 3000 BC, as well as in ancient Greece and Rome. The modern-day method of papermaking (from wood pulp) was first described by a Chinese court official, Cai Lun, in AD 105, but it took many centuries to reach the West, where expensive parchment was used until the Middle Ages: the Missel of Silos, dating from the 11th century, is the oldest known paper document created in Europe.

With Johann Gutenberg's discovery of movable type in Europe in the 15th century, poster-like placards embellished with printed words began to spread. In Europe, the ability to duplicate written materials rapidly led to an information explosion in the Renaissance. But it was the invention of lithography at the end of the 18th century that proved a real milestone in the history of posters. Together with simplified methods of paper production, lithography made the format attainable, and the development of colour lithography in the 19th century enabled the poster to finally make its mark as an advertising vehicle. Though first developed in France, by the 1890s colour posters had spread throughout Europe. Several key artists created poster art during this period — Jules Chéret and Henri de Toulouse-Lautrec foremost among them.

Other innovative processes were also developed in early advertising. Known as the Beggarstaff Brothers, British artists James Pryde and William Nicholson used paper cut-outs to create innovative poster designs. The advantage was that the words were not added until later and the motifs could thus be used several times, which was cost-effective.

Before the outbreak of the First World War, posters were primarily designed by artists. Gustav Klimt and Alphonse Mucha made a

name for themselves in the field of advertising, often signing the poster motifs like paintings. In the 1920s, more and more advertising agencies cropped up, dealing exclusively with the design of advertising material. Posters designed by artists became less and less common.

Offset printing experienced a boom in the commercial sector in the 1950s. Since then, the number of posters in cities has grown constantly, as has the uncontrollable posting of bills in private spaces. To deal with this issue, more billboards and advertising columns were introduced – which proved to be an extremely lucrative business – increasingly overrunning both urban and rural areas. Advertising spaces continue to characterize today's cities, and have turned the poster into one of the most widespread media in the world.

Nowadays, posters primarily advertise concrete products, as well as ideas, events or services. The packaging has to be designed accordingly to add recognition value and distinguish the product from the competition. As mass production has grown exponentially through industrialization, standing out from

Tower, Berlin

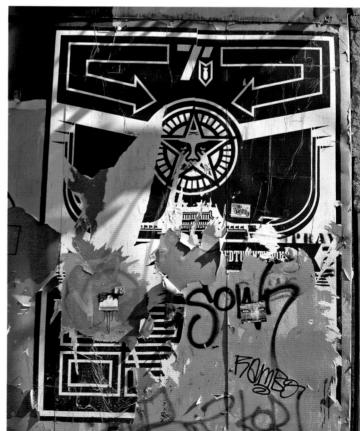

Shepard Fairey, New York City

the crowd has become increasingly difficult. The introduction of colour design opened up new possibilities with the aid of the stencil, as did gum labels, which stuck to objects when lightly moistened – in much the same way as a postage stamp.

When R. Stanton Avery invented the sticky label in 1935, the industry did not immediately recognize the enormous potential of this product. It took twenty-five years for its qualities to be fully exploited. The sticky label, better known today as the sticker, could be printed, stuck to almost any surface, and did not need to be moistened.

Since then, stickers have enjoyed enormous popularity outside the product design field. They are often distributed in political campaigns, or placed on school exercise books, cars and suitcases. Frequently, stickers indicate a person's opinion, tastes or ideals. The modern fascination with the quick, creative design of a surface has expanded the sticker's role far beyond the functional.

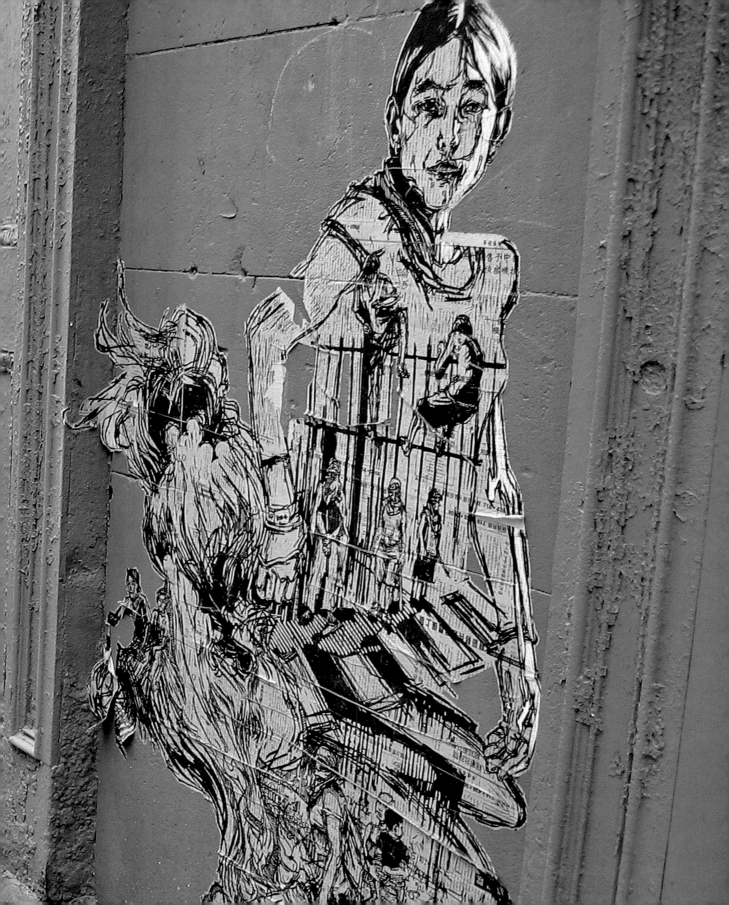

The Leap into Art

In the early 20th century adhesive formats became popular with the Dadaists, and were introduced in public places. By the mid-century individuals and groups of artists were beginning to use posters in protest against the ubiquitous advertising campaigns that were pervading urban spaces. Artists deemed it necessary to take countermeasures, particularly in countries dominated by the market economy, where the poster was almost exclusively used to promote sales. They used the poster medium to exhibit their work to the general public and have their say, particularly in the USA.

In the 1960s artists started to use large-size posters and bill space. The American conceptual artist Joseph Kosuth was one of the first to use advertising space for his ideas, placing thesaurus excerpts on billboards and in the ad sections of magazines.

In the late 1970s, the so-called 'Suicide Club' was founded in San Francisco with a view to throwing social constraints to the wind and trying out new things. Together members took part in activities that they hadn't ever experienced in everyday life. In September 1977 Jack Napier and Irving Glikk attended a club-organized event in which the participants climbed on to a factory roof and altered two billboard messages advertising Max Factor cosmetics. They changed the strapline (from 'WARNING: A pretty face isn't safe in the city: fight back with Self Defense, the NEW moisturizer by MAX FACTOR') to: 'A pretty face isn't safe in this city. Fight crap with self-respect'. Napier and Glikk formed The Billboard Liberation Front in 1977 and did further actions under this name.

Irish-born Les Levine has been working on bringing new art experiences to the public since the 1970s. He became famous at the end of the '70s after introducing a picture of an Asian couple in the New York subway with the caption 'We are not afraid'. Since the 1980s he has covered large billboards in inner cities with his thought-provoking work, combining images with short ironic texts. ➡

Preceding pages: Swoon, New York City

Blues Brothers, Leipzig

Christian Paine, New York City

Shepard Fairey, New York City

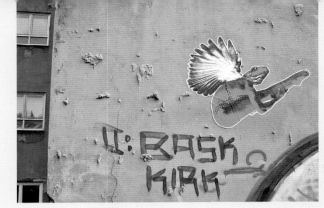

Gould, Berlin

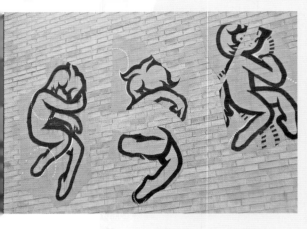

Dan Witz, New York City, 1994

Between 1977 and 1979 Jenny Holzer stuck slogans such as 'Any surplus is immoral' and 'Protect me from what I want' to telephone boxes and the walls of houses within the framework of her *Truisms* and *Inflammatory Essays* series. Fellow American artist Barbara Kruger, meanwhile, is known for using billboards to display her messages in urban spaces. In 1983 she criticized the US population through black, white and red pictorial collages in New York's Times Square, using slogans such as 'I am not trying to sell you anything'.

Only a few of the artists who have worked in public with stickers or posters – largely in urban spaces – have revealed their identities. They generally sent a message out to the public and criticized the world of advertising. Often they felt ill at ease in the white, sterile atmosphere of the galleries. By choosing their own path and forgoing financial incentives, they focused on the works themselves and successfully captured their target audience. However, the greatest creative act of rebellion in urban spaces was the graffiti movement.

The Story of Graffiti

Graffiti primarily refers to spray-painted, written and scratched words or motifs on exterior surfaces. Political slogans, as well as scratched sayings or artists' matchstick figures such as those of Harald Naegeli, are included, although they are not covered in this overview. Most graffiti belongs to the writing movement – the spraying of letters – while figures (known as characters) form a subset.

Back in the 1960s, teenagers in New York and Philadelphia chose nicknames for themselves and started marking their neighbourhoods. A foot messenger going by the name of Taki183 took this to great lengths. On his errands through New York's five boroughs he wrote his pseudonym everywhere he could, and with every type of pen. Over time, his activities attracted more and more attention from the public. Finally, on 21 July 1971, *The New York Times* took note and published a story about him. Hundreds of youths, inspired by Taki183's notoriety, took to the streets to write their own name, and countless 'tags', as they later became known, have been flooding New York City ever since. With the proliferation of tags, it became increasingly difficult to make an impact and gain recognition, and as a result names soon developed into giant, colourful pictures. Graffiti artists caught tags in the most difficult locations, in the hope of earning respect and securing fame among their peers.

Despite the press coverage and an enormous group of motivated youngsters, this form of graffiti would probably never have taken off worldwide without the New York subway. The carriages provided an ideal surface to spread one's name through every New York district and beyond. Photographers Martha Cooper and Henry Chalfant recorded the colourful art on silver steel at an early stage, publishing their pictures and insights in *Subway Art* (1984). Together with the films *Style Wars*, *Wild Style* and *Beat Street*, a worldwide movement was set in motion. Despite strict laws and the risk of prosecution, writers (aerosol artists) show that different aesthetics exist and challenge ownership of public space.

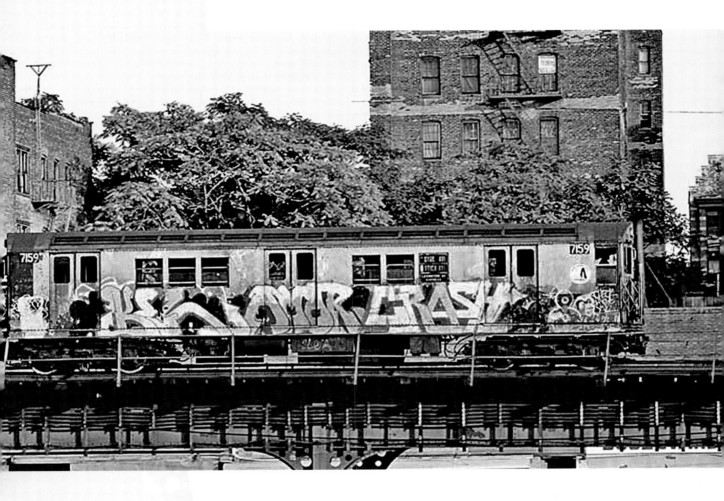

Kel, Amor, Crash, New York City, 1977

Kel, Crash, New York City, 1980

Overleaf: Secret, Paris, 1989

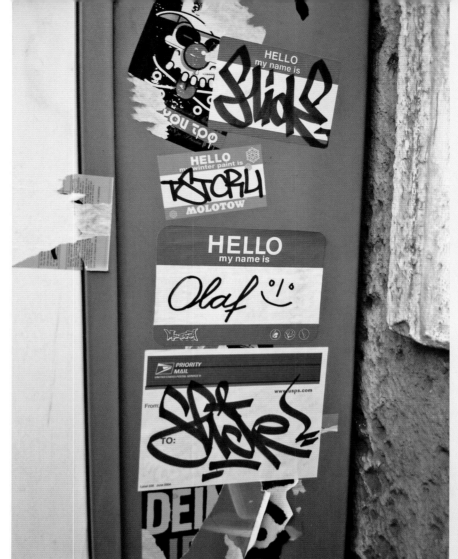

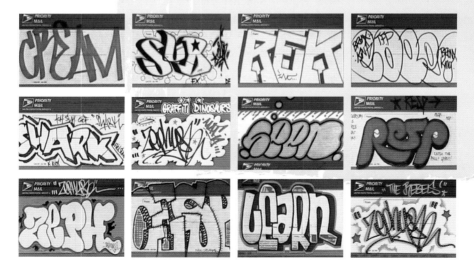

From left to right: Cream, SUB, REK, Cope2, Shark,
Zephyr, Seen, Resp, Zephyr, Cesp, Learn, Zephyr

Stick and Spray

The authorities were quick to act. The state and the public were worried by the general sense that things were spiralling out of control. In 1972 New York City passed an anti-graffiti law in an attempt to put a stop to aerosol artists' activities. The artists, in turn, sought new outlets through which to leave their mark in daring locations. They came up with the ideal solution some years later: postal stickers, which were available free of charge. This format proved the perfect background for tags, as well as laboriously crafted letters and characters. Plus, they stuck exceptionally well and were very difficult to remove: often only the paper surface came off, while the glue layer remained intact. This medium opened up new possibilities of spreading tags quickly, even in tricky spots, with a life span of a few weeks to several years.

A new product, produced by Stanton Avery's company, soon became hugely popular: the 'Hello, my name is...' sticker. Since its launch in the 1960s, this sticker had been used in discussion groups and seminars to encourage participants to get to know one another. The logo attracted artists who wanted to get noticed by as many people as possible, as German bill-sticker artist Gould confirms: 'What's more appealing for a writer than a sticker with the words "Hello, my name is..."?'

The only disadvantage of these stickers was their cost, particularly as artists would often get through them at a rate of knots. Both postal stickers and the 'Hello, my name is...' sticker still enjoy great popularity among street artists. They are liked for their simplicity, although not especially valued for their artistic merit.

The Early Days

The origins and exponential growth of the graffiti movement are relatively well established, but it is far more difficult to pinpoint precisely why thousands of people are now turning to adhesive formats to redesign public spaces. Several individuals have been working for decades with what is now being considered new and different; many are seen as the fathers of the art, having significantly influenced the development of the scene through their ideas.

In the New York of the 1970s and '80s aerosol artists tended to use stickers for fun – a substitute medium, as it were. There were some exceptions to this rule, however. New Yorker Dan Witz, for example, works almost exclusively with adhesive materials and has never been a member of the writing movement, although he willingly interacts with the latter in his art. Thus Witz depicts three-dimensional skateboarders riding along on entwined tags or simply frames spray-painted surfaces. Against this background, the onlooker's perspective of graffiti can alter. Dan Witz says: 'My work

is dedicated to graffiti's beauty. Nobody really risks looking at it. However, as soon as my work comes into play, something that people recognize, perhaps they perceive it.'

In 1979 Witz painted small, photorealistic hummingbirds, at that time directly on city surfaces. In 1980, under increasing pressure from the authorities, he moved on to stickers. This medium enabled him to work out his motifs extensively, and to introduce them discreetly and quickly to the public. In 1981 he painted and stuck his first poster in a subway train. Even today, over twenty years on, Dan Witz is still plastering his photorealistic work in city spaces, primarily in the streets of New York. ➡

Dan Witz, New York City, 1981

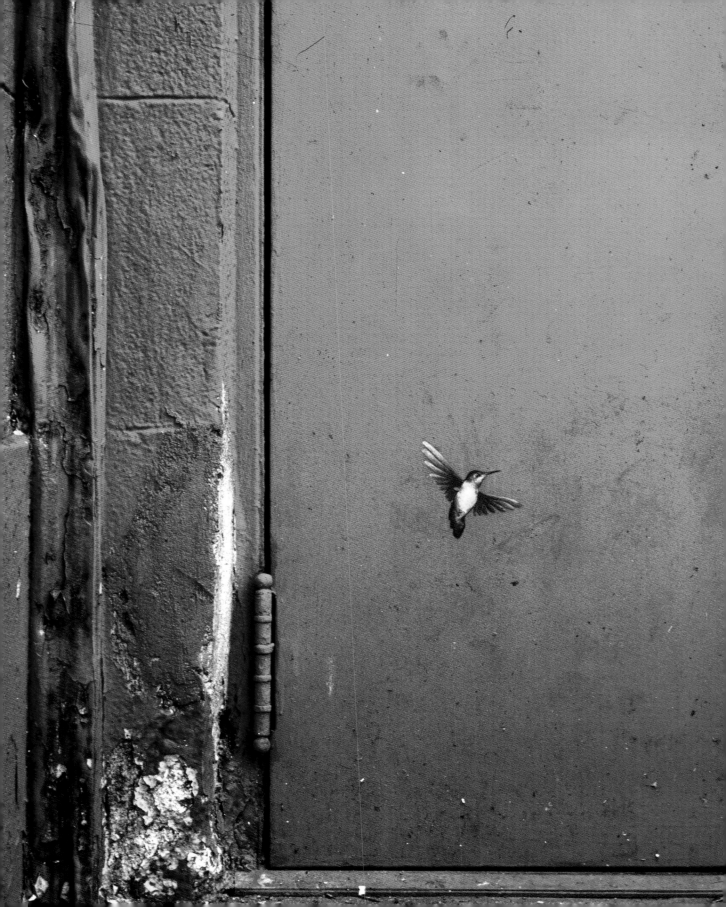

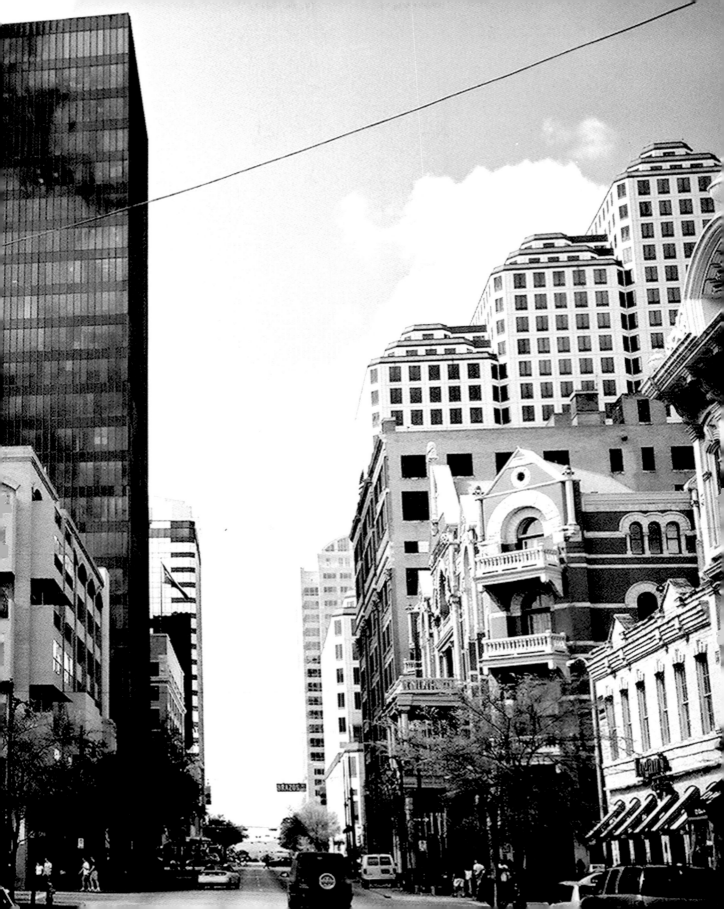

In 1984 Shepard Fairey began to produce his own stickers. At that time, he still used skateboarding and punk stickers as a pattern. When he moved to Rhode Island in 1988, street art and 'Hello, my name is...' stickers first caught his attention. He recognized that this medium was suitable not only for promoting bands and firms, but also an ideal way to introduce oneself. His long search for a motif of his own finally ended when he offered to teach one of his friends how to produce paper stencils. They chose a picture of the wrestler Andre the Giant.

While his friend never finished his stencil, Shepard Fairey completed his own and wrote 'Andre the Giant has a posse'. He started to plaster paper stickers of Andre the Giant everywhere. More and more people asked him what it meant, but Fairey didn't let on. Rife speculation just made the artist and the image more notorious. What had started off as fun had ended up attracting a huge amount of attention. Some time later he branched out further, taking the Giant motif to cities such as New York and Boston. Between 1989 and 1996, he used stickers and posters that he had produced himself. Propaganda slogans such as 'Obey the Giant', 'Power to the posse' and 'You are under surveillance' were added to the iconic image.

According to Fairey, the stickers and posters do not have a particular meaning. Their sole purpose is to cause a reaction and provoke a response. As people generally took the Giant image to be some sort of advertisement, the campaign caused a real stir and was hugely successful. When Fairey moved to California, he started to have his motifs printed professionally, sending them to friends and anyone else who wanted them. Over a fifteen-year period, some 400,000 stickers and posters have appeared in cities throughout the world. New variations of the Giant motif continue to appear today in adhesive formats. Fairey's identity is no longer a secret, although few people now think about the meaning behind the motif as the campaign with T-shirts, skateboards and notebooks has become a product in itself. Fairey formed Studio Number One, his own agency for visual communications, and lives and works in California. ➡

Shepard Fairey, Detroit

In New York, between 1990 and 1995, only one sticker and poster campaign attracted the same level of attention as Fairey's Obey Giant. The graffiti artists Revs and Cost used many techniques to spread their name, including colour rollers and extending poles for their 'roller' pictures. But it was their small, simple black-and-white posters that earned them recognition. Clearly formed, with black block letters that could be easily read, they attracted considerable attention, even outside the graffiti scene, particularly when the duo included a telephone number alongside their names. Passers-by whose curiosity got the better of them would call the number and hear announcements, which changed from time to time. Every so often the voice of an old lady would come on, singing the praises of Cost and Revs; or callers got through to the 'suicide hotline', where they were given the instruction 'Please hang up'.

In 1994 Cost was jailed for vandalism, and Revs went underground for a long time, although he is now working again in New York under his pseudonym. His name appears on three-dimensional, metal objects, which he installs around the city. Revs has remained anonymous right up to the present day, shying publicity and blankly refusing any contact with the art market. ➡

Michael De Feo, on the other hand, makes no secret of his identity, although he is also known by the pseudonym 'Flower Guy' after the flowers that have branded his work. He enjoys talking about his experiences as an art teacher or the twelve years he has spent working in urban spaces. 'At the beginning of the 1990s, the works of Phil Frost, Cost and Revs, and Shepard caught my attention,' he says. 'That inspired me.'

Flower Guy soon took the initiative himself, fascinated by what he was seeing at that time in the streets of New York. Reflecting on his childhood, he developed the idea of his flower, which has since become so well known. The first works were done with stencil and spray-paint. Later he progressed to screen-printing, although now he also works with countless other motifs and materials. However, he avoids using any words in his works: 'When you work in the street, you address every age, every class of society and every race. To be able to reach people of all languages, it is very important for me in my work to renounce the use of language.' By introducing art to urban streets, he sees the opportunity to raise people's awareness of their environment.

Needless to say, American artists were not the only ones to work with adhesive materials in the early days. In Europe, Parisian artist Blek Le Rat was among the most important representatives of early adhesive art, although he is perhaps better known as the father of stencil graffiti, a technique he has been working with since 1981. Stencil graffiti is now widespread, of course, but at the time Blek Le Rat was the only artist in Paris using the technique, which is also known as 'pochoir'. To begin with, he spray-painted swarms of black rats on the city walls, followed by portraits of authors, pictures of bananas and various small figures. In 1983 he became notorious and gained great respect for his life-size human figures. By 1991, after a run-in with the law, he was looking for alternative, less risky ways to take his art to the street. ➡

Blek Le Rat, Paris

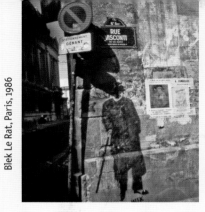

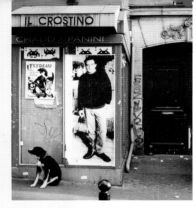

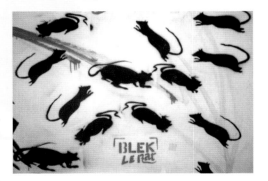

Blek Le Rat, Paris, 1982

The poster seemed the ideal solution. At that time Blek Le Rat used screen-printing in his paper designs. His motifs – portraits and life-size figures – continued to take centre stage. With his enormous stamina and creative strength, Blek Le Rat travelled to numerous countries to spray and paste. His works were admired in France, Germany, Italy, Morocco, Spain and Brazil. Right up to the present day, he has remained a key influence on numerous artists working in the street.

One movement that is reminiscent of today's urban art but has been virtually forgotten over the past twenty-five years is Copy Art (Xerox Art). In the 1960s and 1970s, the first consumer-friendly photocopiers came on the market. Artists were quick to put them to the test, covering walls in America, France and Italy with copies, and in the 1980s many German artists followed suit. They experimented with moving print during the copying process, copying three-dimensional objects or even producing entire 'copy generations' – the copy of a copy, and so on. Artists tended to use copying as just one facet of their versatile techniques. Even the New Yorker Jean-Michel Basquiat is said to have used this method. The formats used by today's artists can generally be found in the works of that period. Even in 1980 individual small sheets were arranged to form large pictorial motifs based on photographic images, or the motif coloured after copying.

In the latter half of the 1990s, numerous artists promoted adhesive art. Key figures include Influenza, active in Rotterdam and Paris since 1994, and the Cowboys Crew, whose impact was primarily confined to the Berlin area, as well as Akay (Stockholm) with his posters, the first stickers by Fume and Magic (Düsseldorf) and Space3's (Netherlands) posters. Only the most important representatives from the past twenty years are covered here – pioneers who began to produce stickers and posters themselves, introduced them to urban spaces, and left a permanent impression on the scene.

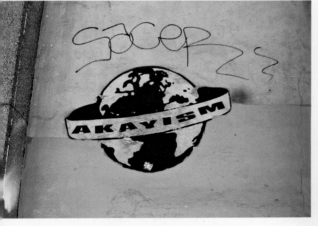

Akayism by Akay, New York City

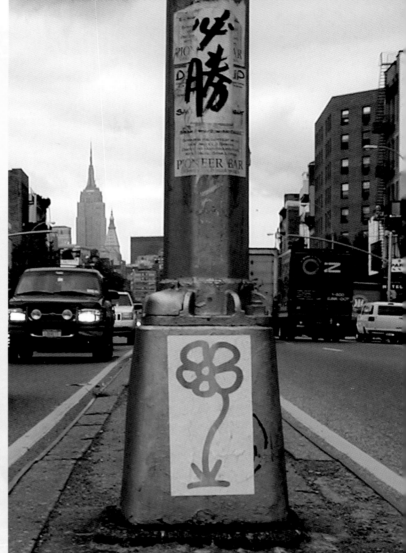

Flower Guy, New York City

CBS, Berlin

From Individual to Subculture

From the pioneers of the adhesive scene to the influences that have moulded it, the development of poster and sticker art has been stimulated by a multitude of different factors. These days there is a fertile base on which to draw: young people who have been schooled by the graffiti movement perceive urban space in a fresh, lively way and have few reservations about making their own mark. The aesthetics of city life and advertising are increasingly being questioned. As youngsters strive to fulfil their potential, individualism has become one of the most sought-after traits. ➡

Thundercut in action

Möe in action

Mello in action

▸a beautiful crime

G, Paris

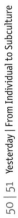

When home computers and the Internet started to take off in the 1990s, technology sparked a revolution. Although no one at the time could possibly have realized the scale of its impact, for many people the Internet has gone on to overtake classic media such as newspapers, radio and television as the primary source of information. It is no longer simply the media that decide what information reaches us; we can decide for ourselves what we want to read, see and hear, and we have a worldwide audience at our fingertips.

Over the years, computers have also become amazingly affordable, even for the most meagre of budgets; printers and digital cameras are so convenient and easy to operate that they have become essential gadgets in the modern household; and there are so many sites offering space for uploads and downloads, email or blogs that we almost take them for granted. 'I think that we owe everything to the Internet,' says Dan Witz. 'People have learned to handle technology,

and now millions of people around the world can see what we do here in New York.'

Photos posted on the Internet have enabled millions of people to gain access to adhesive art. Inspired by what they saw on the Web, individuals were able to test out their own ideas through modern technology, such as the home printer – even if rain then caused the ink on the first lovingly placed stickers to run the very next day, the initial steps had already been taken.

Computer software such as Corel Draw and Adobe Photoshop have proven innovative aids: artists can take a photo, scan it and then use Photoshop to turn it into an image that is made up of black dots; this makes it look more graphic, and less like a photograph. Modifying other people's pictures and sticking countless copies around town is also easy, though it often doesn't require a great deal of creative talent. 'It's like music,' says Dan Witz. 'We live in an age of sampling. It is no longer difficult to recycle existing objects, and everybody can do it.' ➥

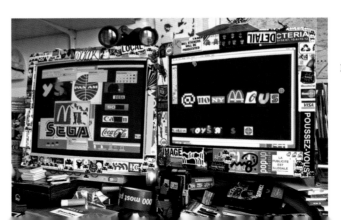

Invader

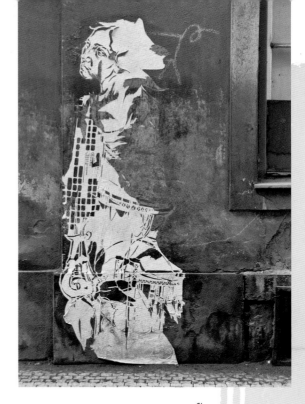

Improvements in travel over the past decade or so, both in terms of affordability and choice of destinations, have also benefited the fledgling scene. It was not simply a case of travellers becoming artists on the basis of what they saw; in many cases, artists travelled to numerous world cities with posters and wallpaper paste in their luggage. New York artist Swoon, who has been renowned for her life-size, cut-out figures since the end of the 1990s, frequently travelled – for instance, to Berlin, to take part in exhibitions and beautify the city with her elegant posters. Her influence there is not to be underestimated. Word spread of Blek Le Rat's travels, as well as the proliferation of the Obey Giant motif. The London Police, from the Netherlands, are well known for their perfect circles drawn with black markers, partly thanks to their extensive travelling. ➡

The London Police, Tokyo

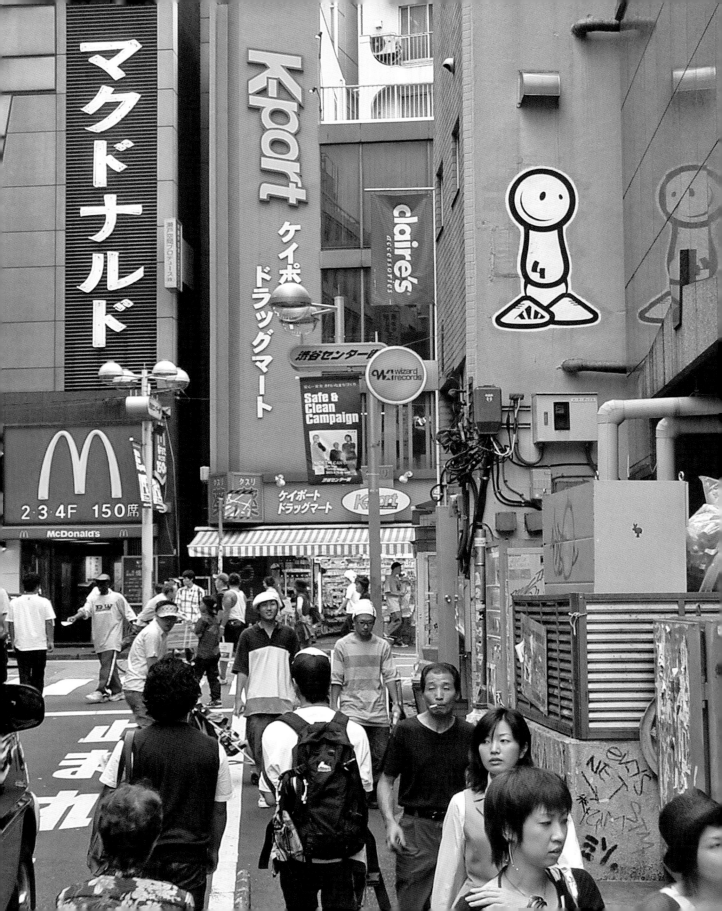

In many countries where graffiti has flourished, the grip of the law seems to tighten year on year. But ironically, rather than wiping out creativity, the widespread crackdowns have actually helped the scene to evolve. Many of adhesive art's foremost representatives were (or still are) active in the field of graffiti. With the responsibilities of adulthood, particularly for aerosol artists with families of their own, adhesive materials offered a fresh artistic outlet: they allowed writers to continue to indulge their creative flair, but with far fewer risks. Many authorities have responded by adding the illegal placement of bills to their anti-graffiti laws, although the penalties for graffiti are generally much more severe as spray-paint is a lot more difficult to remove. 'One day I was caught tagging and ended up having to do community service,' explains Berlin-based Tower. 'I had no intention of putting myself through that again. Then, I discovered postal stickers and thought, "Well, you can spread your name this way too."'

At the turn of the 21st century, the combination of all these factors favoured the development of a new, exciting subculture, driven by a small, scattered group of artists. As Martha Cooper says, 'It was time for something new.'

Preceding pages:
G, Paris

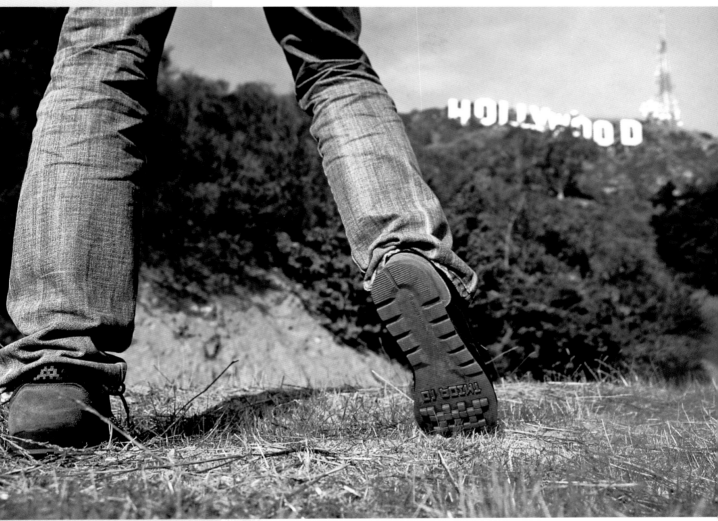

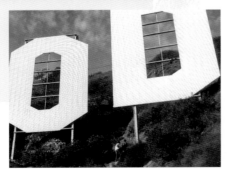
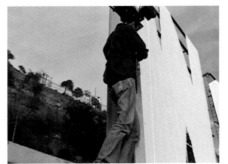
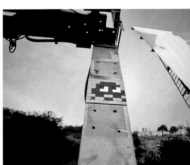

Invader, Hollywood

Chapter Two

Earning Respect

Whenever you walk through a city these days, you never know what treasures you may come across. Stickers and posters can change the entire character of a street overnight; among the monotony of advertisements, you see the glimmer of an artwork that has been lovingly created by hand. Likewise, the artists' scene is continually evolving. ➡

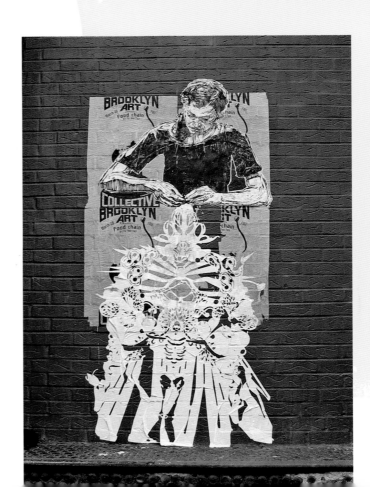

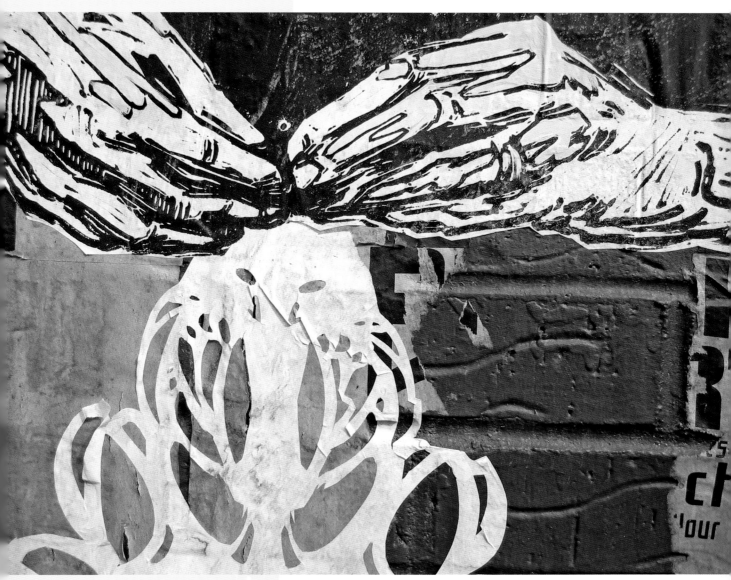

Swoon, New York City

Thundercut at work

Graffiti has left a distinctive mark on the modern cityscape. To post metre-high letters on every surface, writers have little choice other than to rely on their spraycan skills and their own physical strength. No machine can truly replicate the spray work.

Adhesive art can require far less effort, but this throws up problems of its own: if there is poor craftsmanship, then the quality of the artwork suffers and with it the value given to adhesive art, particularly by the general public. Whoever places value on an individual mark can hardly renounce craftsmanship, particularly when it has to compete with advertisements. Whether we're talking photocopied drawings, stencil motifs or freehand pieces is immaterial.

Taking the time to come up with an inspiring concept is what counts in this scene if you want to earn respect. ➡

Invader at work

Nevertheless, none of the adhesive works illegally displayed in public lasts for long. Virtually no other art form has such a short lifespan – that continual cycle of creation and destruction that paper and adhesive materials generally go through. Rain, wind, sun, snow, poor-quality glue, aggravated caretakers and cleaners...all can take their toll. In fact, artists often see it as a bit of a bonus if their works survive longer than a month. Lindas Ex, from Berlin, sums it up as follows: 'Let's say that you stick up a hundred posters a night – then the next morning fifty will have disappeared. The following week another twenty. A further twenty may still be around in a month, and the remainder will survive for two or three months at the most. Stickers last a bit longer, depending on where they are placed.'

Aerosol artists often photograph their work in order to keep some sort of record, although this form of documentation may not be very practical for prolific artists. Over time, artists grow accustomed to the continual disappearance of work that has often taken weeks to prepare. 'You remain humble when engaged in street art as your work doesn't last,' confirms Flower Guy. 'You paste something outside, only for it to disappear. You produce something, merely to give it away.'

On the other hand, the process of decay actually appeals to some artists. 'I have done some stencil graffiti,' explains Swoon. 'The colour is extraordinary. Nothing has happened to it, except that it has faded a little. Paper, on the other hand, is like an organism, changing, rolling, stretching and developing new elements in connection with the surface. A new work of art is created every day through the process of decay.'

A work of art is sometimes created for a particular spot. The artist begins by searching for the right place and then creates the picture. In practice, locations that guarantee a longer lifespan are preferred. This is more difficult with posters than with stickers, which are often stuck to objects that are seldom cleaned such as gutters or the backs of traffic signs.

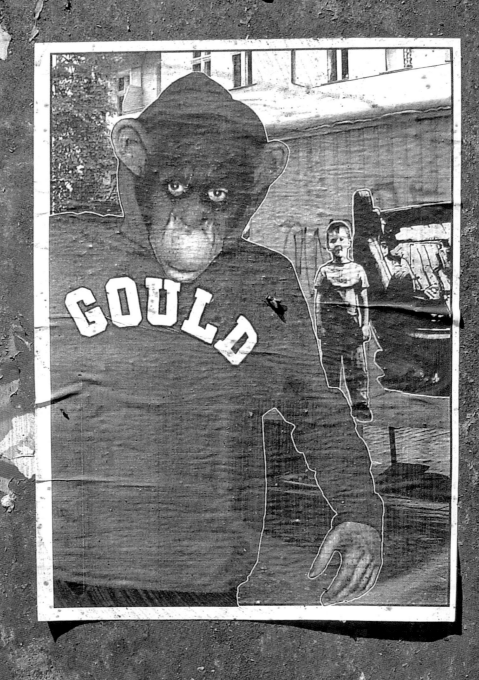

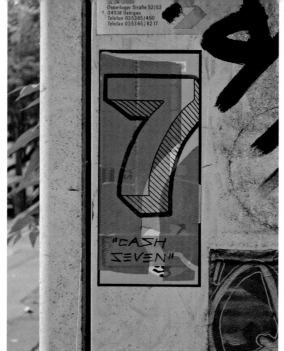

All stickers by Cash, 7 Crew, Halle

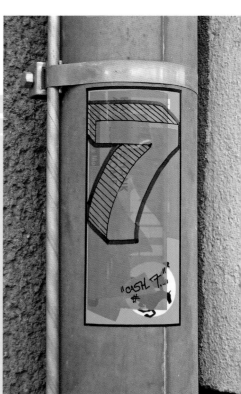

Target Audience

Walls are the ideal canvas for many forms of art. But although pieces are there for all to see, they are not always accessible or comprehensible. The graffiti world has been aware of this for decades. An artist may employ the same methods as an advertiser to spread his name, but only rarely are the general public able to decipher the letters; and even if they are successful, the meaning often escapes them. Frequently only those involved in the scene itself can read a piece or understand its significance.

This is the essential difference between graffiti and adhesive art. The search for fame and honour among a select few is no longer the only motivation for working in the street; the sheer joy of reaching out, entertaining or surprising also comes into play, as Chaz of The London Police explains: 'I would like to make as many people as possible laugh, without resorting to selling them anything or demanding anything from them.'

Urban art is no longer the preserve of a fortunate few. With adhesive art people can feel integrated, have an instant connection with the motifs, and can make interpretations of their own. As a result, stickers and posters have tended to find more favour with the general public than graffiti. 'Compare street art with graffiti, and you have a totally different audience,' say the Blues Brothers. 'When spraying, you are used to rejection. You only find recognition in the scene. Suddenly, other people are appreciating street art too. It's an interesting experience.'

Urbanites often stand in front of the images in contemplation, experiencing a whole range of different emotions – from amazement or surprise to amusement. New Yorker Thundercut says: 'If someone has had a bad day and finds one of our clothed figures on a traffic light on their way home, and it brings a smile to their face, then we have brightened up their day. Surprise and joy are our motivation.' ➡

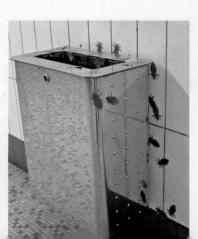

Nadine, Hamburg

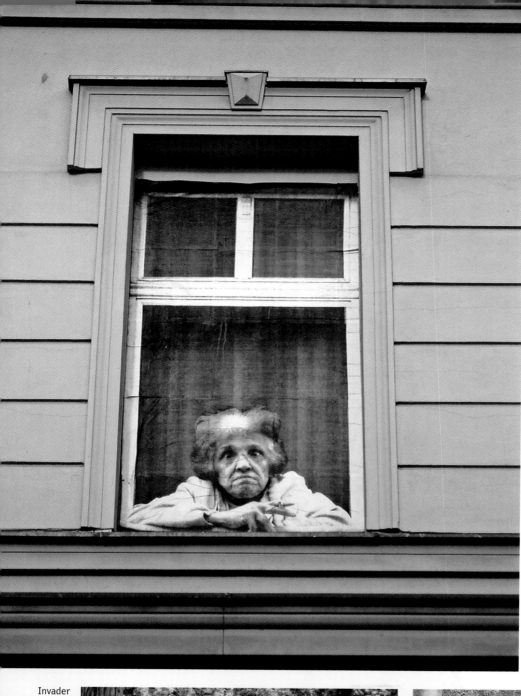

Acht, Berlin

Invader, Barcelona

Invader

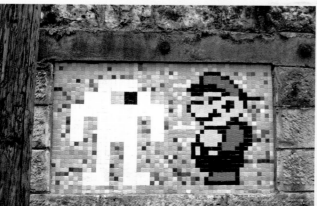

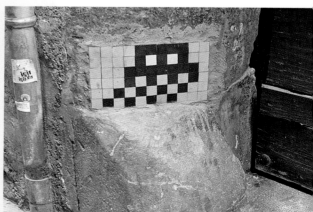

Some works have such great mass appeal that they inspire the public to spring into action and participate. This happened in 2003–4 when Lindas Ex plastered stickers and posters around Berlin, pleading with his lover to come back to him. On hundreds of posters he declared his love and bewilderment, and asked for assistance and support. This 'real-life' soap opera in the street triggered a huge response. The inhabitants of one whole district tried to work out who Linda might be and whether it really was her ex-boyfriend distributing the stickers and posters.

'The reaction was huge,' says Lindas Ex. 'For a while it came in waves: people sympathized with me, and then once again with Linda. They stuck little notes next to my posters or wrote directly on them in biro. Messages such as "Leave poor Linda in peace!" or "You psycho" and, of course, "Sexist" too. I even took part myself and made posters with the words "That is enough", or destroyed my own posters and tore them down.' Even newspapers and radio stations took up the love story, which turned out to be imaginary.

As well as reaching out to the general public, artists often communicate with one another. On countless posters Lindas Ex asked other artists for their help in looking for Linda. They reacted in turn by placing response posters next to his. By sticking your own motif next to someone else's, you are merely saying hello. Adhesive artists don't tend to have the harsh competitive streak that you often find in graffiti; there's more a sense of mutual encouragement. ➡

The Wallstreet Journal, Berlin

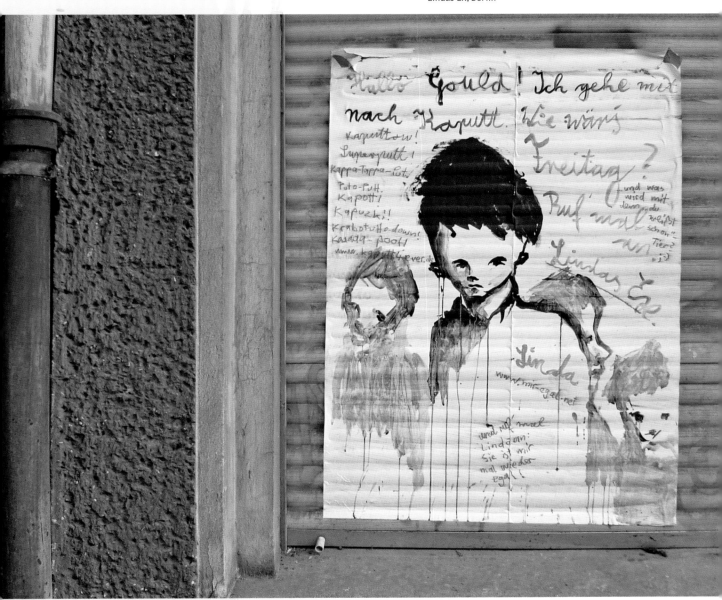

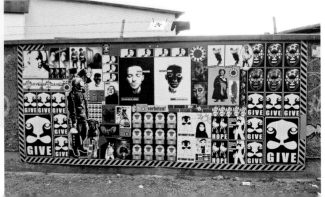

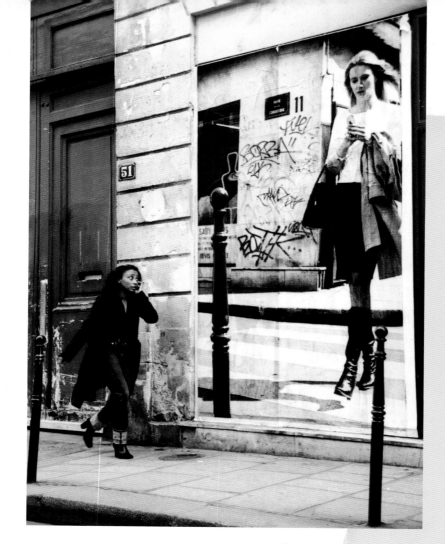

G, Paris

G, Paris

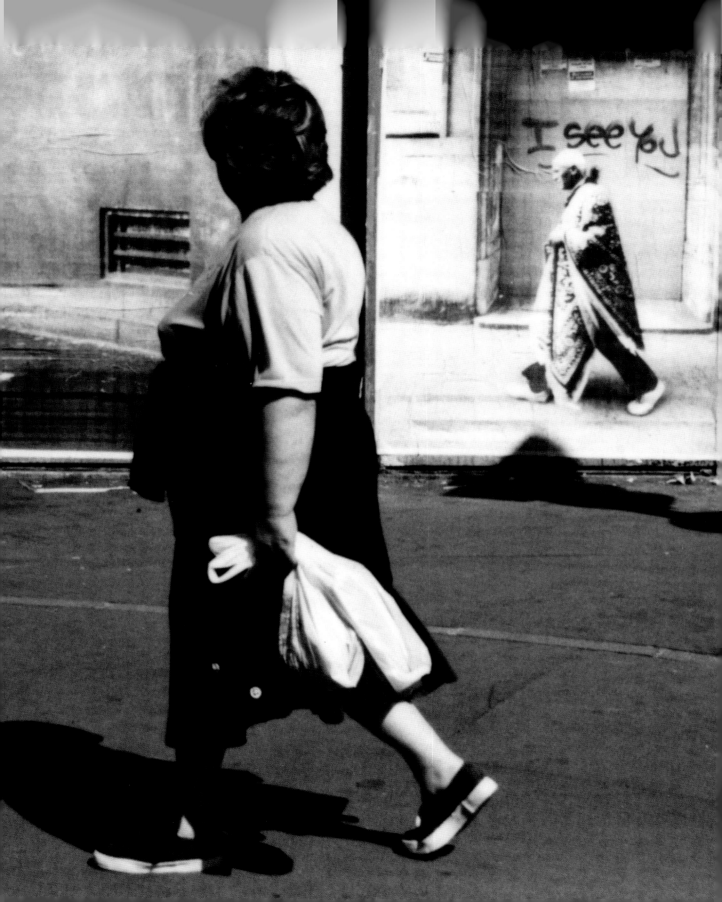

Many street art projects would simply not work within the framework of a gallery. Urban artists frequently place considerable importance on context – i.e. where the pictures are placed in a particular town. In this scene, there is a widespread rejection of the traditional exhibition space, which is often perceived as cold and elitist; in galleries a work of art experiences total isolation from the space that surrounds it, and there is a widely held belief that this detachment leaves visitors feeling inhibited and empty. Many artists feel that the inherent freedom of street art is smothered in such a sterile environment.

Swoon has often felt uncomfortable in the gallery scene: 'I started working in the street because I was bored of the galleries in New York and felt alienated.' Dresden-based NoLogo tries to break down negative preconceptions about art: 'In the street I work predominantly for the general public,

as they are the ones who think that art is very intellectual.' Moreover, it is virtually impossible to maintain that crucial element of surprise in an exhibition space, according to the Blues Brothers: 'People who are open to art go to galleries. It is much better when people who do not expect to encounter art come across it. It is important for us that art is brought to the people, not vice versa.'

Thanks to the scene's drive, whole cities are being converted into exhibition spaces. Gould says: 'I always see Berlin's streets as a type of gallery facing outwards.' He also sees it as his task to educate those members of the public who are interested in street art by supplying background information. Together with two friends, Bild and Aem, he initiated *The Wallstreet Journal*, a street newspaper in the truest sense of the word. There is nothing like it – neither as a book, nor on the Internet. Fans search for it at the various illegal and legal poster sites in Berlin. New editions can

be found there regularly with interviews, columns and, of course, adhesive art. With their black-and-yellow frame, they are easily and quickly identifiable in the street.

Despite objections to official spaces, over the past few years there have been numerous exhibitions of graffiti and street art. Ideals aside, galleries are often a good way for artists to reach the public.

Ironically, others were only driven to street art in the first place by the shortage of exhibition spaces, as Lindas Ex confirms: 'One of the most important reasons I moved on to the street was the lack of exhibition spaces here in Berlin. Yet the Linda issue would not have worked in any other venue!'

Artists who do not agree with the concept of galleries, and thus avoid them, try to eradicate these aspects in their exhibitions by incorporating the rooms themselves into the works of art, just as they would do in the street.

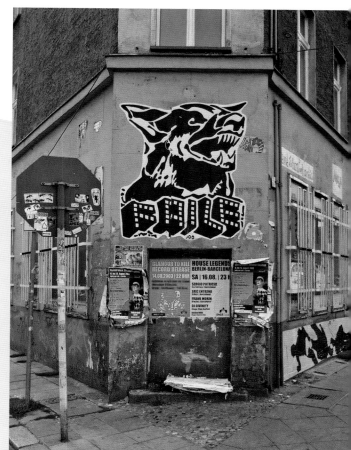

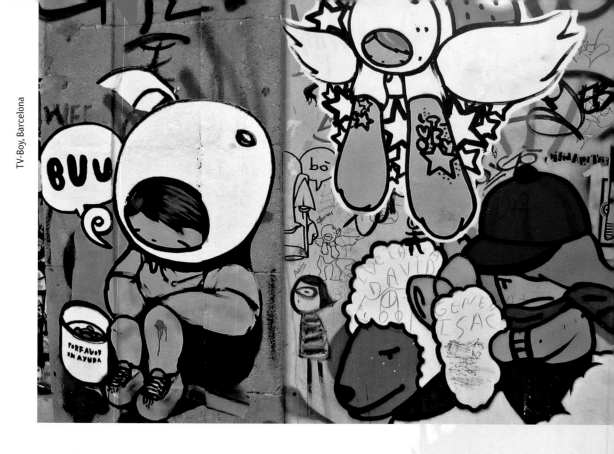

Karl Toon, Barcelona

The London Police, Barcelona

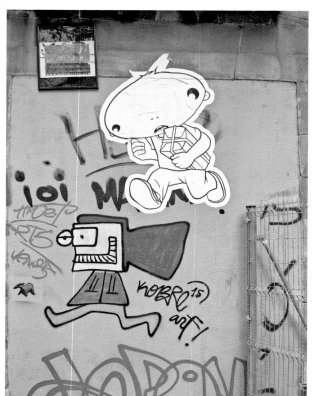

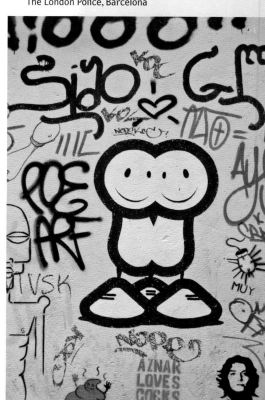

Symbols

While graffiti artists usually sign their pictures – or, even better, the image itself becomes their mark – adhesive artists only rarely identify their works. NoLogo says: 'I find it amusing when you put your work all over the city, and nobody knows who did it. As they aren't signed, people can only guess.' The artist's identity often remains a mystery to anyone unconnected with the scene. As a result, many artists have developed their own style or created a character, as a kind of signature. Often the most recognizable images have a particular graphic style, and a simple but sharp concept – although as many artists are professional designers, this may come as little surprise. Many strive for recognition by distributing as many works as possible, but others deliberately try to avoid this approach. Dutch artist Influenza, for example, uses numerous techniques and forms of expression to surprise the passer-by time and again, and avoids typical advertising means, although even he uses a pseudonym to identify his works. Pseudonyms are an integral part of the graffiti scene, where most of the work is illegal.

Such unwritten rules tend not to exist in the adhesive culture. However, sometimes out of habit former graffiti artists have been known to sign their stickers and posters. Blues Brothers say: 'Initially, we stuck small stickers with our name in the corner of the poster. That's what we were used to, but we've stopped doing it now.'

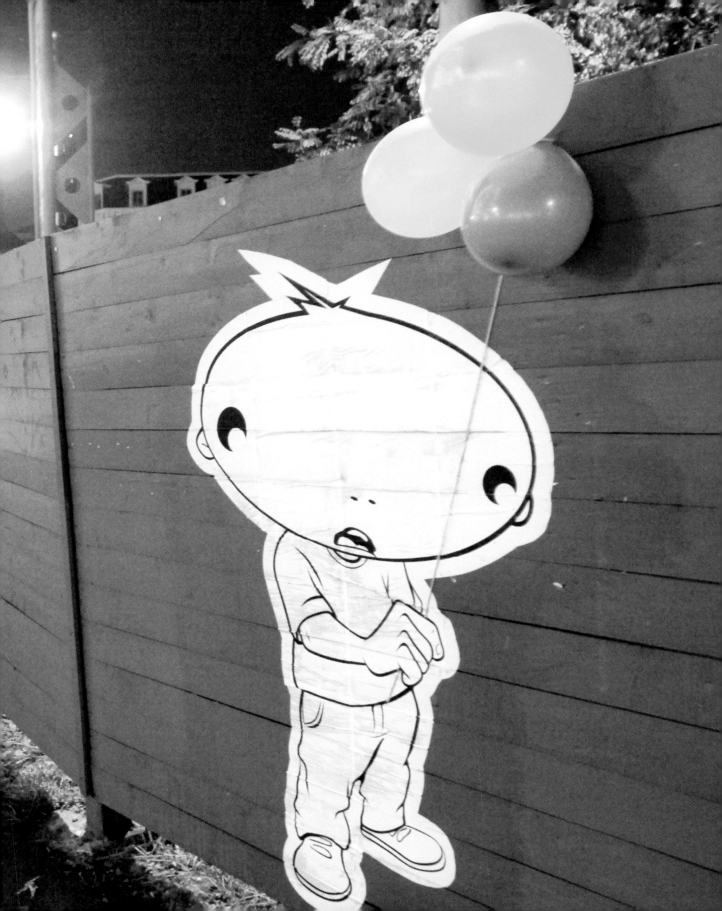

Risky Business

In art circles graffiti is often not recognized as an art form; and despite having made some headway with the general public, many people continue to perceive it as vandalism. People tend to see graffiti artists as representatives of a youth culture that likes to vandalize, rather than serious artists. The average age of writers – whose career frequently begins at the age of 12 and ends as early as 20 – could be a reason for that. An adhesive artist generally approaches the scene from an adult perspective. The average 20- to 35-year-olds have a far greater sense of responsibility than teenagers, and are reluctant to run the risks associated with graffiti. The authorities tend to penalize the graffiti culture with a great deal more severity than the adhesive subset, even though the law generally views them with equal disdain. 'To date I haven't had any problems,' says Swoon. 'I simply talk to people, and then they don't feel the need to call the police.'

However, many artists have spent long spells in custody or have had to pay high fines.

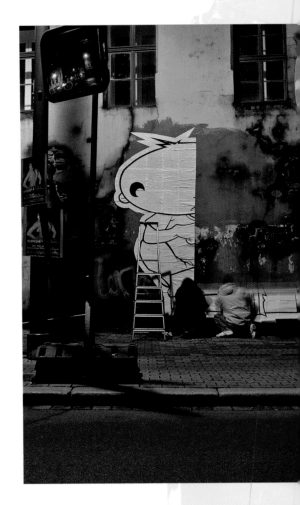

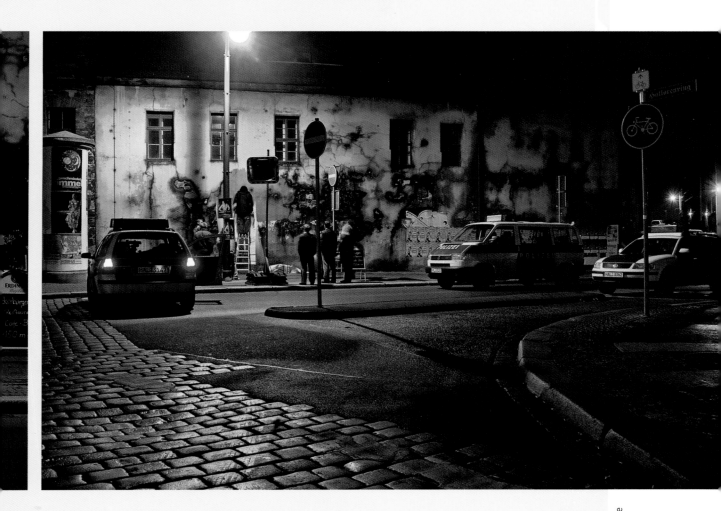

Karl Toon and the police

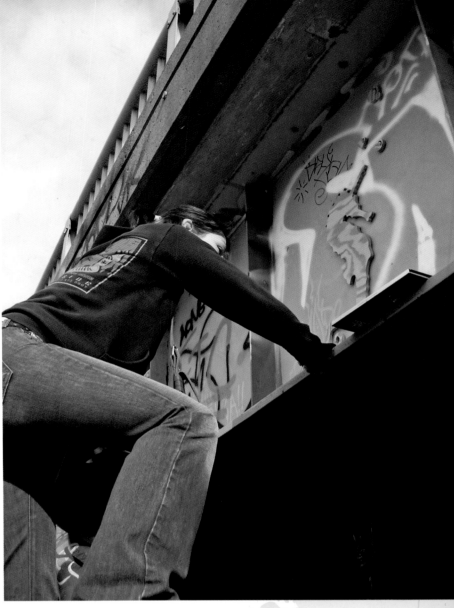

Invader in action

Undeterred, Swoon does something that would be inconceivable for a graffiti artist: she sticks her art to walls in broad daylight, right in front of passers-by. This is not unusual in the adhesive art scene. The faster you work, the lower the risk. Whereas an aerosol artist may need ten minutes to create a large two-colour piece, a skilled poster artist can complete his work in under two minutes. Thus the quality of a spray-painted picture is often inferior to that of a poster, which is prepared at home and can be very detailed. If adhesive art isn't up to scratch, it doesn't have to be shown in public and can go straight in the bin.

The pressure to prove your worth right there, with nothing to fall back on, is removed.

Considering the many issues associated with the urban scene — such as safety, acceptance in the community and its rules — it makes sense that adhesive art continues to draw in more and more people. And although men dominate the scene, more women are also becoming active. 'I have never understood graffiti writing, with all its rules,' explains Hamburg-based Nadine. 'Always spraying the same name everywhere would be too monotonous for me. Street art is much more open and varied.'

The London Police in action

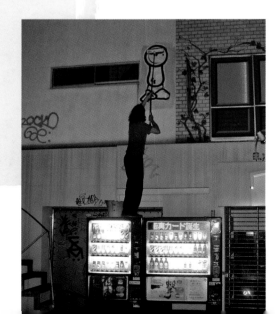

Techniques and Secrets

When you decide to stick something to a wall, you have a broad range of materials to choose from. Wallpaper paste and paper, the classic adhesive materials, are used most frequently, but wooden or foam figures, Styropore pieces and ceramic tiles can also be stuck in the most unusual places around town. Sometimes public appreciation of an artist's work is linked to its technical application – Swoon, Invader and The London Police being prime examples. Some of the most common methods of production and placement are detailed here.

Pash*, Prague

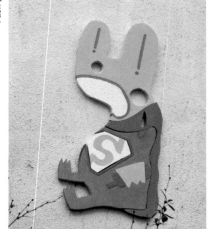

Pin 2011, Berlin

Glue

Poster art must be quick to paste up, hold fast to the wall and be cheap to produce. In order for adhesive art to make the maximum impact—and therefore survive for as long as possible—artists often spend years developing their own secret glue recipes.

Alternatively many artists buy wallpaper paste, which generally does the job perfectly well. Adding too much water can make the paste too weak for outdoor use. Latex adhesive makes the mixture dry watertight and gives the poster some protection from the elements. Some artists add wood glue, while others have experimented with ground glass. 'There are people who would have no trouble talking for an hour exclusively about wallpaper paste,' explain the Blues Brothers. 'How you mix it, and how best to apply it.'

The cheapest and most ecological ingredients for making glue are available in any supermarket: flour and sugar, mixed with water and then heated. This mixture —better known as wheat paste—is the perfect adhesive. In especially cold temperatures, add a pinch of salt.

Blues Brothers in action

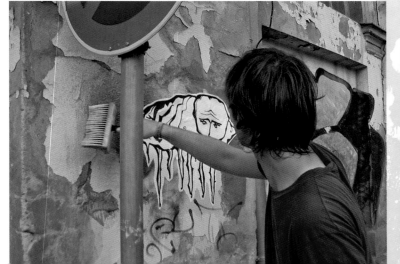

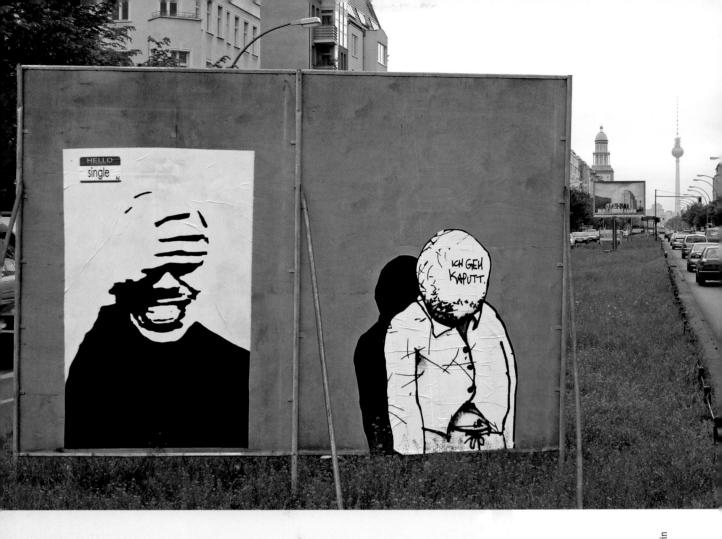

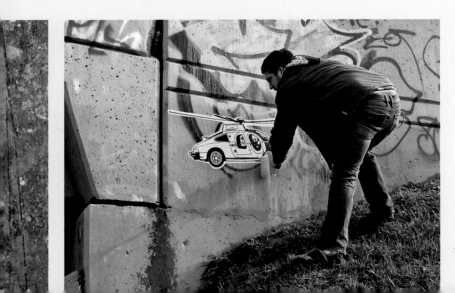

Thundercut in action

Paper

Paper is one of the most diverse media. As an artist needs endless quantities of the stuff, cost is often the most crucial factor, and looking out for cheap or even free paper is the norm. Old newspapers are ideal, as is parcel paper. Even scrap paper can be used. However, so that the paper sticks to the wall, be it an internal or exterior surface, it must not be too thick; otherwise it may simply fall off again once the glue is dry. Paper that is too thin, on the other hand, often tears when the wheat paste seeps through it.

Artists who use photocopies in their work regularly divide their motif into several sections which are copied individually in a larger format and then assembled. Different approaches have been taken to try to ensure that this process runs smoothly. Wherever possible, artists try to do as much of the work as they can at home. However, the best method is to stick the sheets together directly on the wall with paste — then they stay up for longer. If the sheets are assembled at home, a glue pen is a really useful additional tool as the wallpaper paste can soak through the glue and the paper.

To individualize their own poster, make it stand out in the sea of advertising campaigns but also integrate it more into the environment, most artists cut out the figures they assemble. These posters are known as 'cut-outs'.

Solovei, Berlin

Buff Monster, New York City

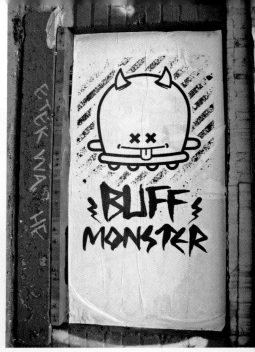

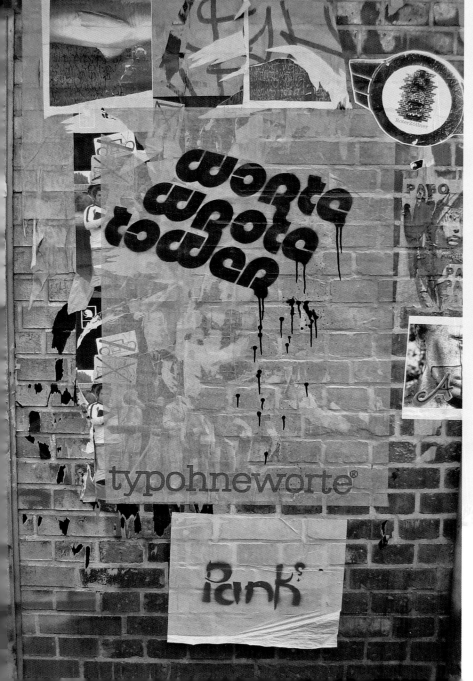

Möe, Berlin

Tower, Berlin

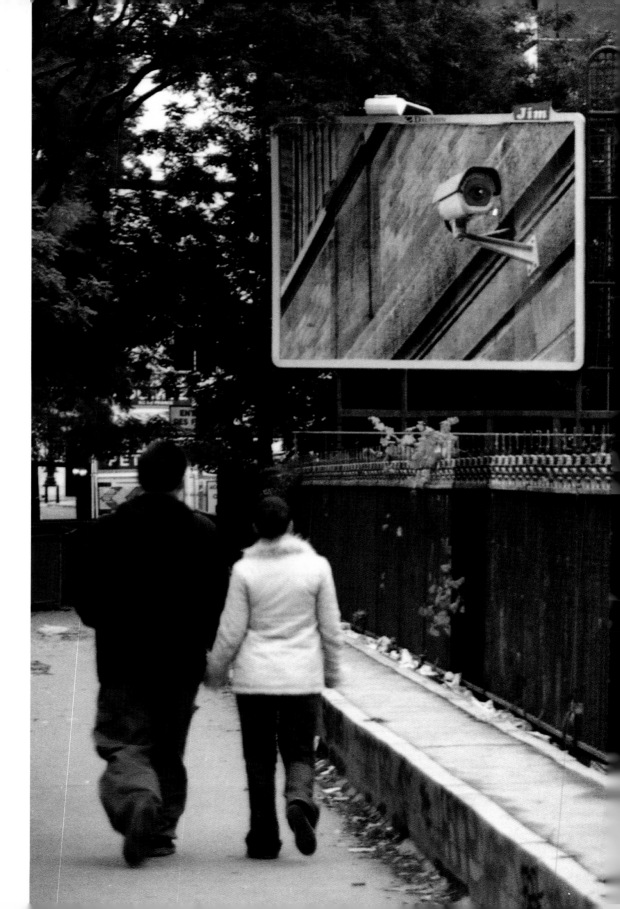

G, Paris

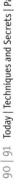

Stickers

Only a few artists have found their way into adhesive art via posters. Virtually everyone designed their own stickers to start off with. In many cases, their first attempts bore only their own initials – their tag.

'I started off posting stickers,' says Tower. 'Posters were somehow too hot for me – you need to use wallpaper paste and carry it around with you. Stickers, on the other hand, can be distributed quickly.'

Of course, artists don't actually make the self-adhesive paper or vinyl; they buy the base materials. Paper stickers are thin and highly suitable for urban surfaces, but this does mean that they weather quickly. Vinyl stickers, on the other hand, resist the elements, but they do not stick as well and can therefore come off more easily.

As has already been mentioned, some free materials such as advertising stickers, badges and postal stickers can also be effective. Artists like treating advertising stickers with spray-paint before designing them, although spray-paint flakes the more it dries, especially on even surfaces. These stickers therefore do not last very long.

Some labels react to the solvent in pens as well as to aerosol. 'The surface of some stickers we had reacted when deodorant was sprayed on it,' confirm the Blues Brothers. 'It had a kind of misty effect. From that point, we always treated them with deodorant before painting them.' Postal stickers continue to be very popular. ➡

Shepard Fairey, The London Police, London

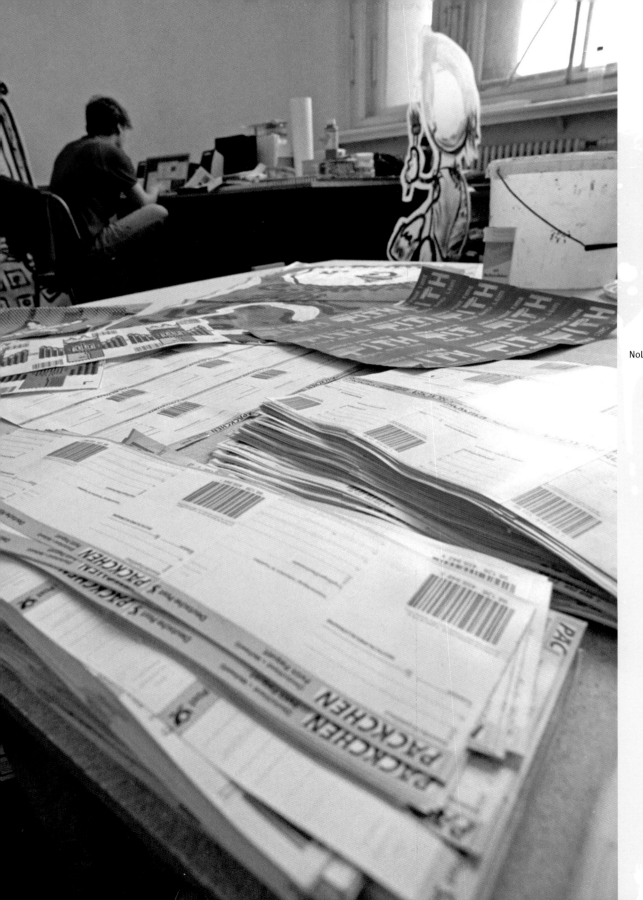

NoLogo at work

Lowlita, Foxy Lady, Amsterdam

Tower at work

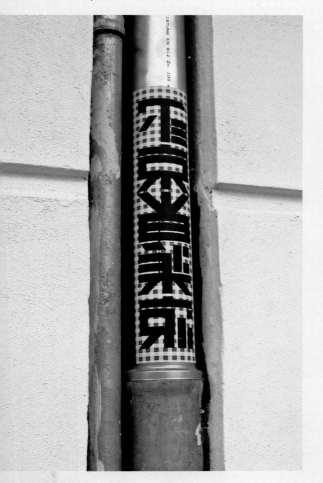

Tower, Berlin

Paper stickers can be combined with all sorts of colours and materials, and will still adhere to almost every surface. 'They are simply the best stickers!' says Tower. 'You can even stick them when it's wet. Just try that with other stickers.'

A number of artists even glue together postal stickers to form enormous surfaces or banderols, which can then be decorated. 'When I work with stickers, it's always with postal stickers,' says NoLogo. 'I then stick them together to form enormous sheets, some of which are made up of 600 pieces. Then I use the screen-printing technique.'

In some large towns the popularity of postal stickers reached such a height that local post offices developed new types of glue that were totally unsuitable for street surfaces and would only stick to parcels.

Möe at work

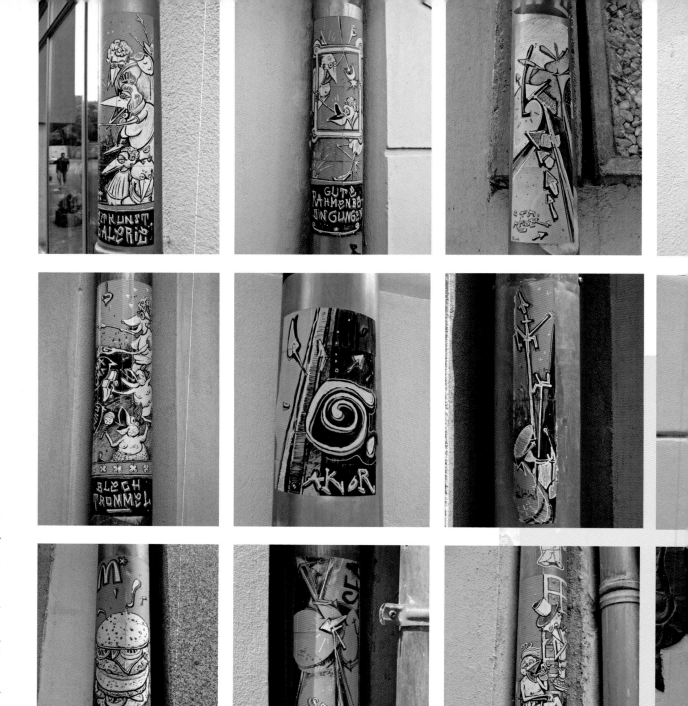

All stickers by Akor, Halle

Paint

Most stickers and posters are black and white. Not only can the combination of the two produce striking effects, but the widely used photocopying process is only cheap if works are reproduced in black and white. It doesn't matter what kind of paint you use, whether it's acrylic or enamel, oil or ink. Artists basically use every type of durable paint for outdoor work.

Swoon, who works with linoleum and woodcuts, uses oil-based paints, which survive the effects of weathering particularly well. Many artists prefer acrylic paint, but it dries very quickly and is therefore unsuitable for certain techniques. Other artists like to experiment. By painting his posters with water soluble gouache, Lindas Ex hoped that the colours would gradually fade with rain. The experiment was only partially successful as the colours ran, leaving splotches of the motif here and there, but it wasn't completely washed away.

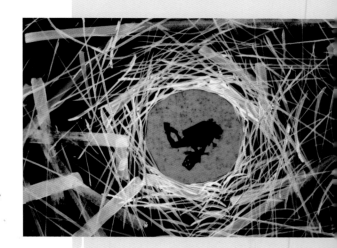

Flower Guy, New York City

FUCK YOUR CREW, Kaktus Crew, Berlin

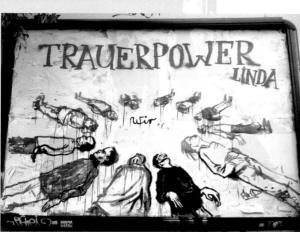

Lindas Ex, 'Camp Kleister', Berlin

Gould, Berlin

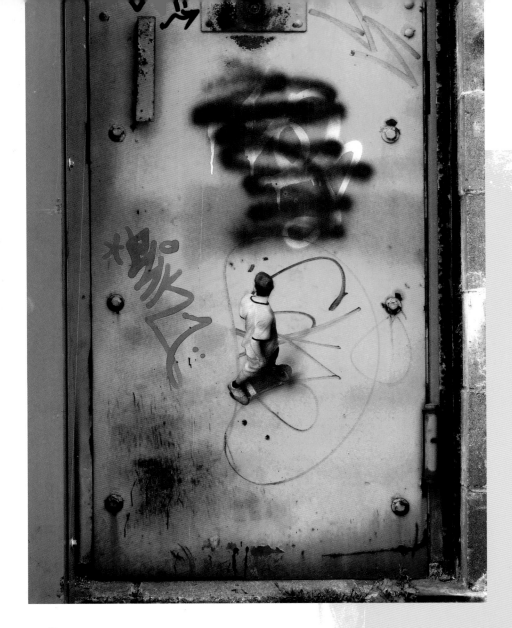

Dan Witz, New York City

Dan Witz, New York City

Stencils

The stencil is popular among artists and is considered by many to be the best street technique. Postal stickers, in particular, are often stencilled. Many materials lend themselves to the manufacture of stencils; the ultimate decision depends on how often the image is to be reproduced. A thin paper stencil buckles after the first or second application. Cardboard, thin plastic sheets, strong transparencies and even thin metal tend to be preferred. A knife or scalpel is used to cut out the stencil, with a glass or wooden sheet underneath. It's important to do this on a firm surface — otherwise it's impossible to cut straight lines and clear shapes, and you run the risk of ripping the stencil in places. Connecting bridges are either carefully cut out in the stencil itself or (as is increasingly the case) stuck on at a later stage just before the motif is spray-painted.

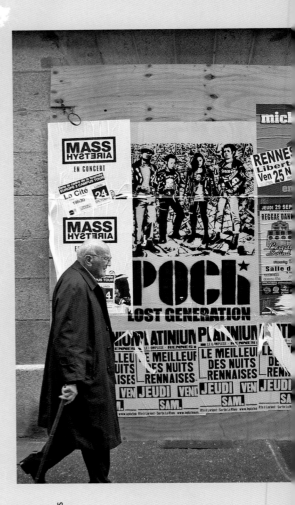

Poch, Rennes

Möe at work

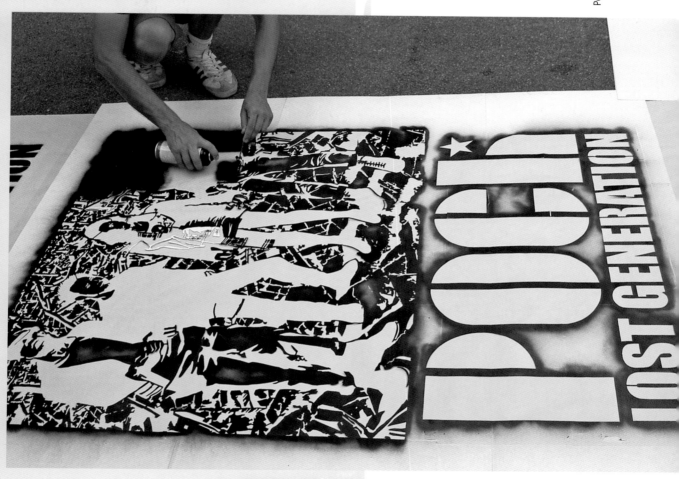

Stencil by Mello

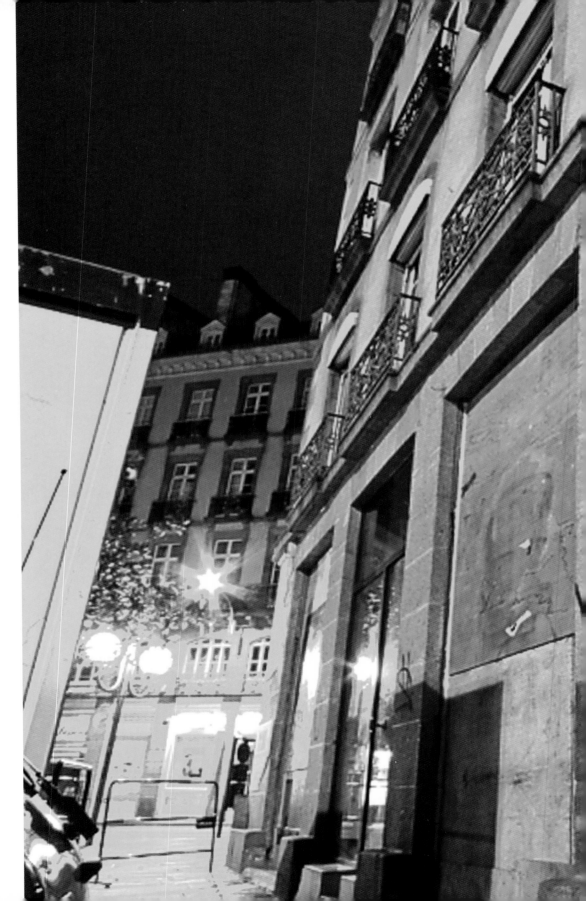

Poch, Rennes

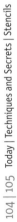

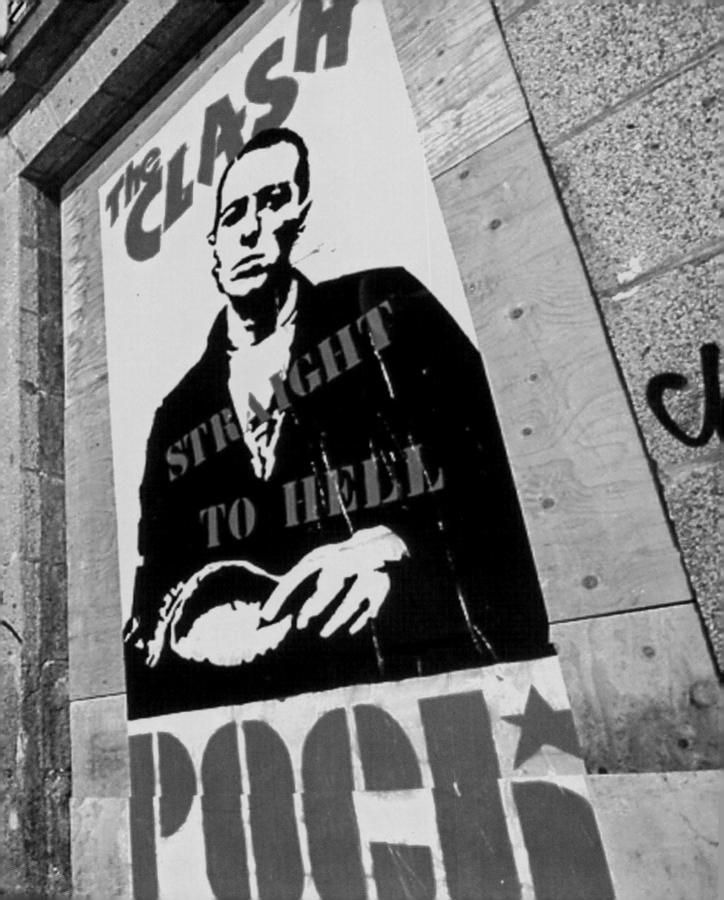

Stamps

Individual stamps can be made from all sorts of materials. Artists generally avoid particularly hard media, although if the medium is too soft it can soak up the colour and cause the stamp print to blur. Rubber is the simplest and most economical material for producing stamps. Creative artists will embellish a section of rubber with a drawing, cutting away the areas that are not to be printed at a slight angle. Ink or paint can then be applied to view the end result. Tower is one artist to take advantage of the range of opportunities in the stamp field. For example, he cuts his name out of a wide piece of foam and then attaches it to a roller, which enables him to create posters in a matter of seconds.

Tower, Berlin

Tower, stamps

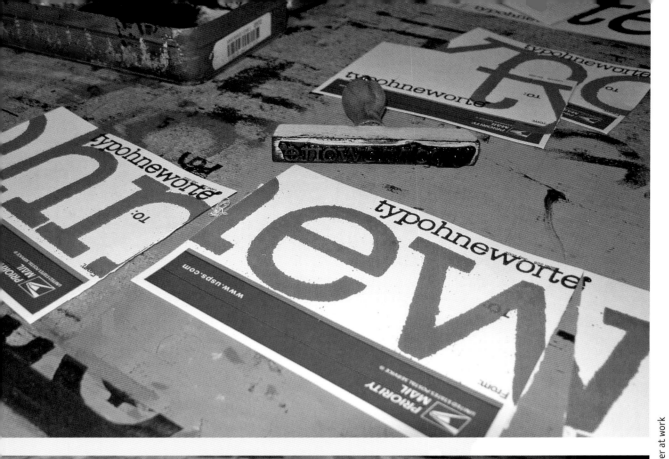

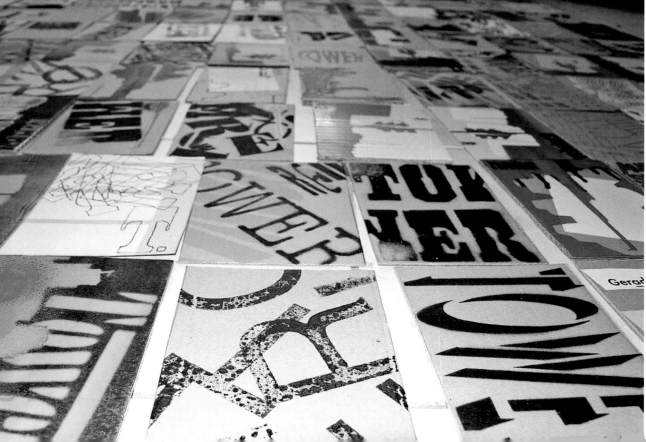

Tower at work

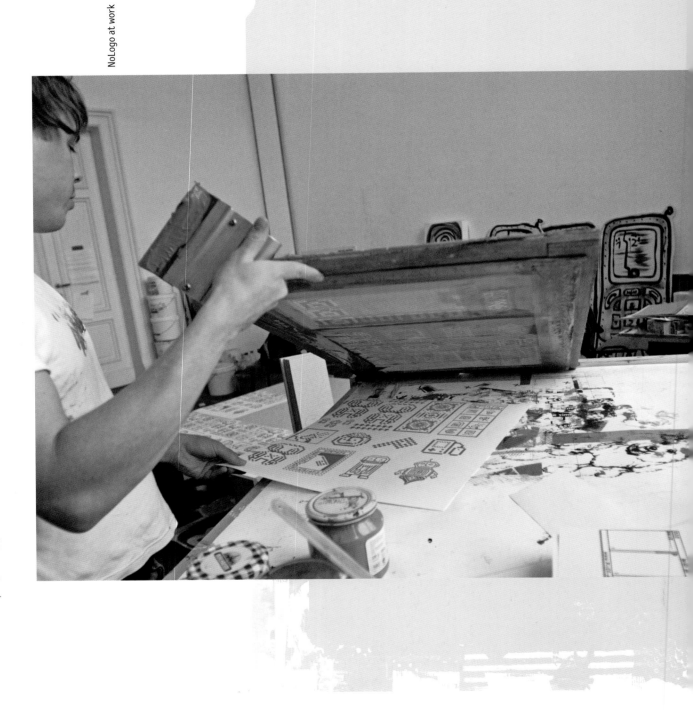

Screen-printing

Screen-printing is probably the most professional reproduction technique employed by street artists, who are constantly looking for ways to cut down the costs and speed up the process. NoLogo, for example, is building his own screens from old window and door frames in order to save money. Technically screen-printing falls into the stencil category: paint is pressed through a fine mesh using a rubber blade, and areas that are not to be printed are blocked off using a non-permeable material; various methods are used, including masking areas with solid media and painting the negative image on the screen with a filler such as industrial gelatin, which dries under strong light. Large numbers of stickers and posters can be produced by artists at home using this technique.

NoLogo, screens

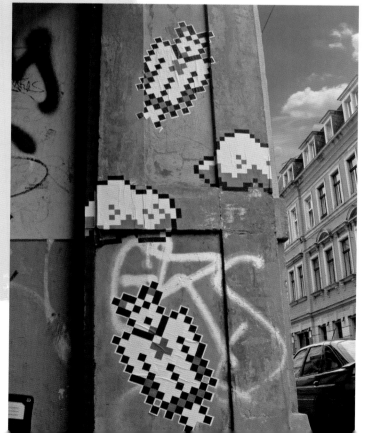

NoLogo, Dresden

Putting It Up

Putting up posters can be difficult. Everyone develops their own technique to minimize any problems. However, the basic procedure is the same for everyone: first you spread the adhesive on a large surface of the wall, then you stick the poster to it and add another layer of adhesive. A brush, generally large and soft, is used on easily accessible areas. A wide, soft broom with a long handle is an essential tool for posters that need to be particularly even or high up. Paint rollers are not used to secure posters as they often have the opposite effect. Whichever method you prefer, you have to carry your bucket, brush and posters around with you.

There is considerable speculation surrounding Swoon's technique. Her very detailed posters, with their numerous perforations, appear much too fragile to be hung on the wall using the traditional method. 'It is better to cut lots of small holes in the paper rather than a few large ones,' explains Swoon. 'This way the paper is still very fragile, although not nearly as much as you may think. I roll up the works from the top and take them to the wall. Then I cover the wall with glue, stick the poster at its base, rolling it upwards. When it is stuck to the wall, I paste it down with glue. That's it.'

Thundercut in action

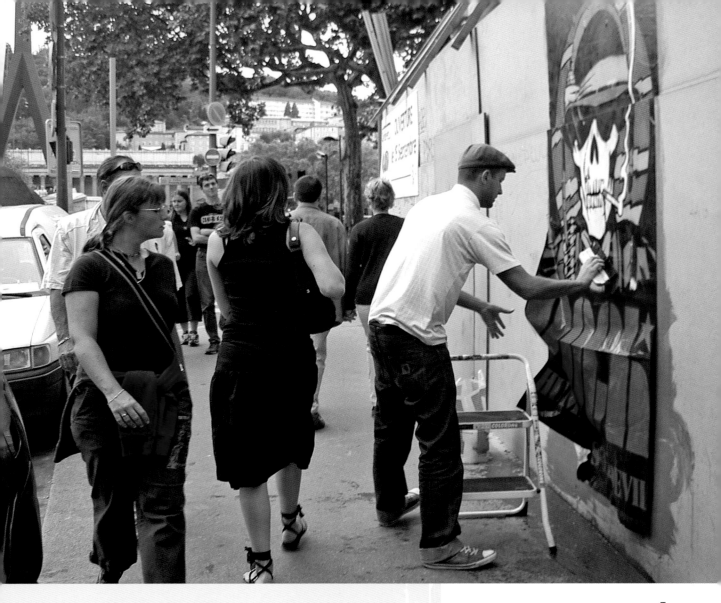

Poch in action

Karl Toon in action

Thundercut in action

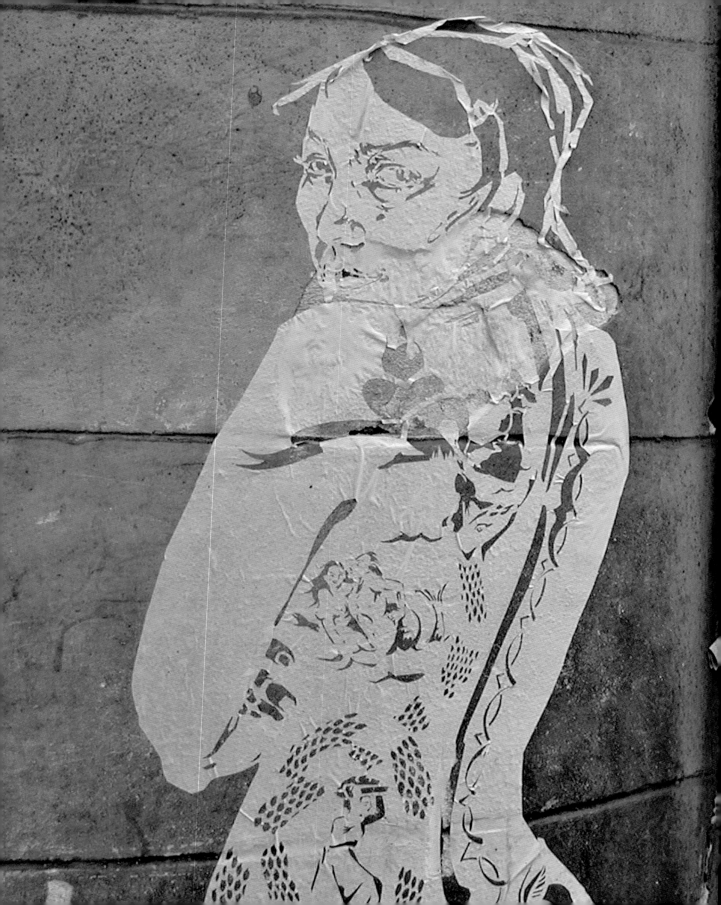

Artists and Artwork

This section touches on a selection of creative projects from around the world. The artists' inspirations are as varied as the materials they choose. Almost all of them use a pseudonym, rather than their actual name; others have become known by their motif but have kept their own identities a secret.

G
Lepos
Thundercut
D*Face
Bild
Flower Guy
Gould
Blek Le Rat
Above
Karl Toon
Dan Witz
Tower
Lindas Ex
Swoon
The London Police
Pash*
NoLogo
56K
Blues Brothers
WK interact
Poch
Mello
Invader
Shepard Fairey
Influenza
Yok

Bild, Berlin

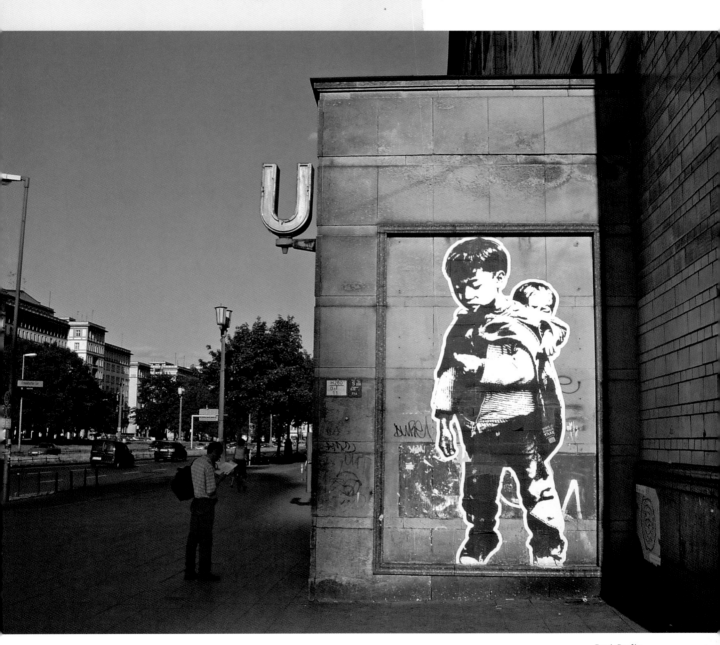

Boxi, Berlin

G

Paris, France

Sometimes you have to look hard to find a piece of street art. At other times, it just jumps right out at you, as in the work of French photographer *G*. Selected locations in the city frame the enormous black-and-white pictures as if they were exhibits in an over-size gallery. He often uses advertising spaces to display his hugely effective photographs. To be able to put them up as quickly as possible, *G* copies the massive, enlarged photos on to huge sheets (300 cm long x 80 cm wide); five pieces are needed to cover the entire surface. Since 2002 he has been transforming the streets of Paris with his very own over-size portfolio. While many of his posters are portraits and street scenes, others question aspects of modern-day life: one was inspired by *1984*, George Orwell's gloomy vision of a state that is under total and constant surveillance. Every one of *G*'s photo-posters plays with perception.

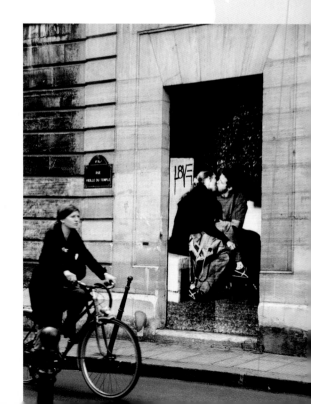

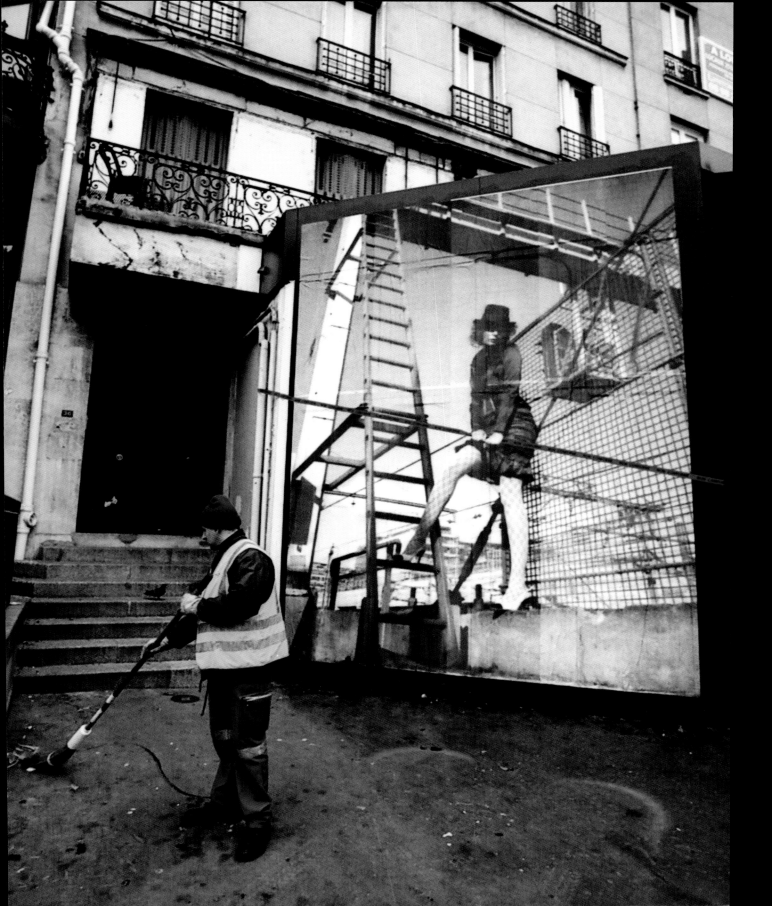

LePoS

Toronto, Canada

Several years ago, a small, friendly, extra-terrestrial creature called Lepos landed on our planet for reasons that remain a mystery. Since then, he has been conducting a number of adventures in our very midst. He is said to be on the run, fleeing from one place to the next. His father, who lives in Toronto, loses track of him every so often; when this happens he distributes missing person leaflets in the hope that a member of the public might know where Lepos is. Thanks to the huge support from vigilant citizens, every search effort so far has had a happy ending. Lepos has called upon up-to-date technology—the software Maya—to give him the right weapons and equipment for battle. As he tries to find his way back home, he is bound to pass through a town near you—so keep your eyes peeled!

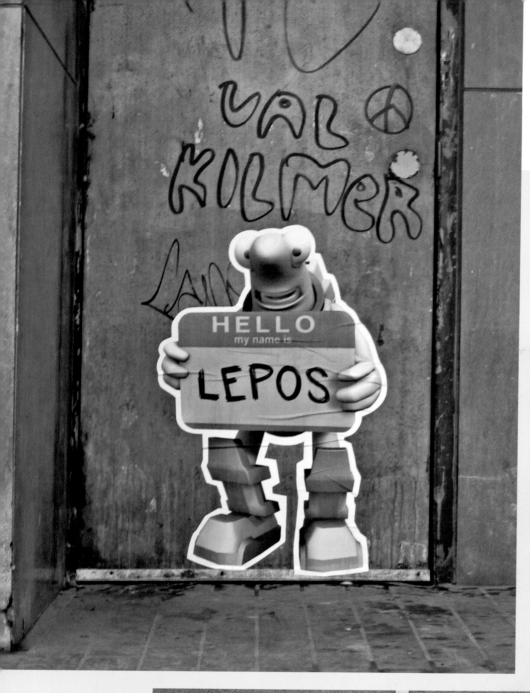

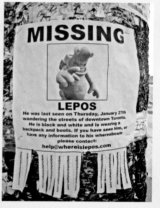

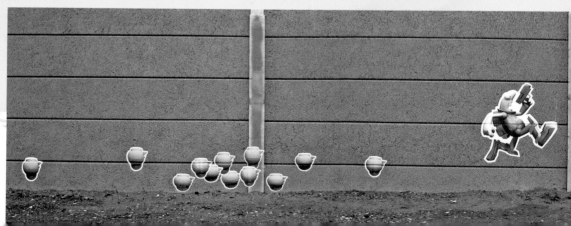

ThUNderCuT

New York City, USA

In New York you are likely to find yourself on foot more than in any other American city. But even if you are a true New Yorker or familiar with the modern pedestrian crossing signals – a white figure in mid-stride for 'Go', and a red hand for 'Stop' – you may come across something unexpected. More and more of these figures are being spotted around town wearing elaborate outfits and accessories. They are dressed by a design couple from Brooklyn, who spend hours creating the detailed outfits: coloured vinyl pieces are carefully cut out and assembled, with tiny holes for the dots of light that make up the figures; the costume is then stuck to its allocated model. Whether it's a punk in front of the legendary CBGB club, a baseball player at the Yankee Stadium or a girl laden with her latest purchases in SoHo, they are enlivening the city in their very special way.

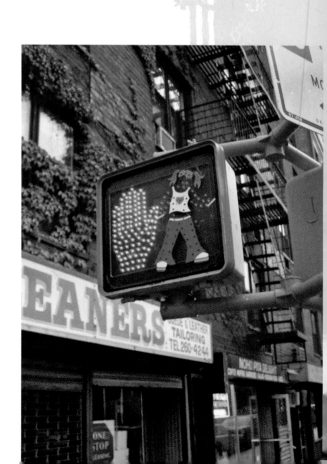

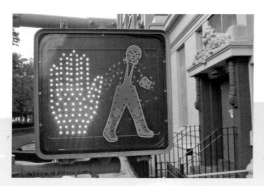

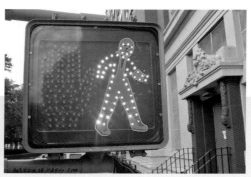

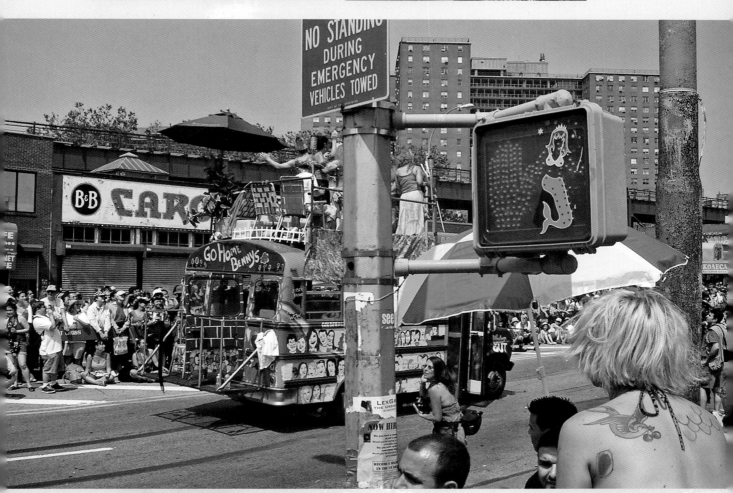

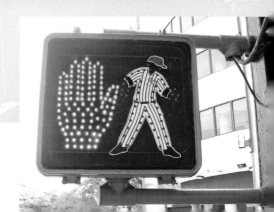

D*FAcE

London, UK

You don't need to travel to London to see
D*Face's figures, which regularly pop up all
around Europe and New York. At the end of
the 1990s, while looking for alternatives
to the spraycan, D*Face turned to adhesive
formats and stuck his characteristic black-
and-white figures in as many places as
possible. They have since appeared on traffic
lights, guttering, lorries, walls and even giant-
size on bridges. Described as a mixture of
cute and ugly, they love splashes of paint and
graffiti. D*Face took a golf ball as inspiration
for the spherical, winged 'Balloon Dog', his
most familiar character; in the poster *Prey*
he recycled the famous Obey Giant motif in
an amusing way, with Balloon Dog imitating
Andre the Giant. Whichever of his figures you
encounter in the street, they all have one
thing in common: we don't observe them;
they observe us.

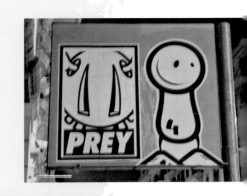

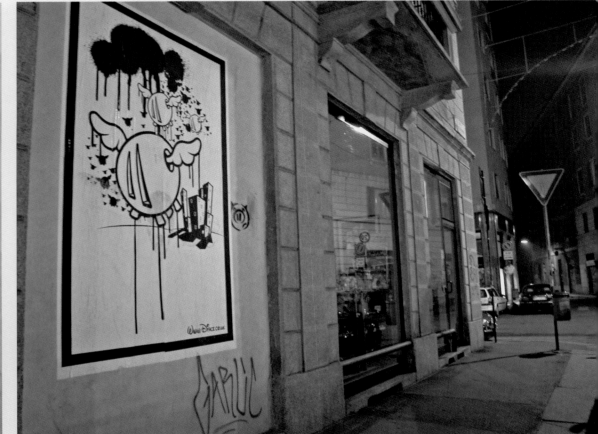

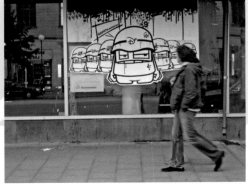

BiLD

Berlin, Germany

After leaving the graffiti scene, Bild
abandoned his tag and went anonymous.
While looking for a new inspiration, he came
across the German term *Bild*, which means
'image'. Since then, he has been playing on
this word and its meaning in stickers and
posters. Initially he signed his work with
a symbol, leaving out any reference to the
term; ironically, fellow artists soon started
to call him Bild off their own bat. He paints
self-portraits, but never reveals much of his
own face, which he covers with his hands. With
black, white and red acrylic paint, and the use
of an overhead projector, he has created one
strong image after another. The striking sizes,
colours and locations of his pictures show us
how, in the battle between advertising and
street art, the artists often win.

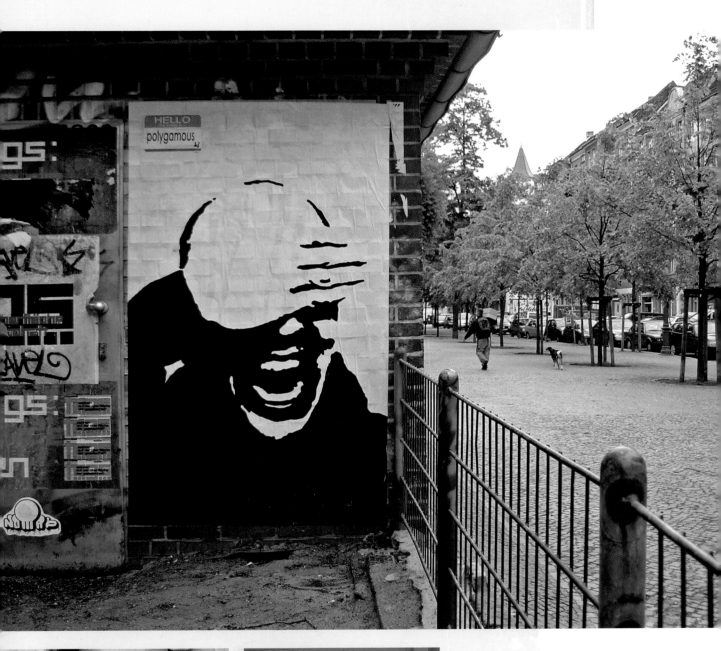

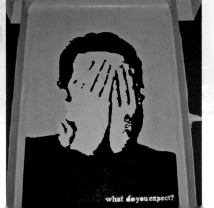

FLoWeR GuY

New York, USA

No one has ever presented as many strangers with flowers as Michael De Feo, aka Flower Guy. The monochromatic floral motifs, reduced to clear forms on a plain background, are particularly popular with children, and Flower Guy often paints them in accessible spots with kids in mind. As a teacher and author of the children's book *Alphabet City*, Flower Guy appreciates his young audience both professionally and artistically, and his own childhood experiences and training at a New York art college inspired him to develop a universal sign language that could be read by everybody, irrespective of age or nationality.

Flower Guy's work takes him to many countries, but he feels the strongest connection with New York; and he has made such a significant contribution to its vibrant street art scene, with countless stickers and posters, that he has become part of the city. Watch the video for Joe Cocker's 'Hot Town, Summer in the City' carefully to see just how true this is.

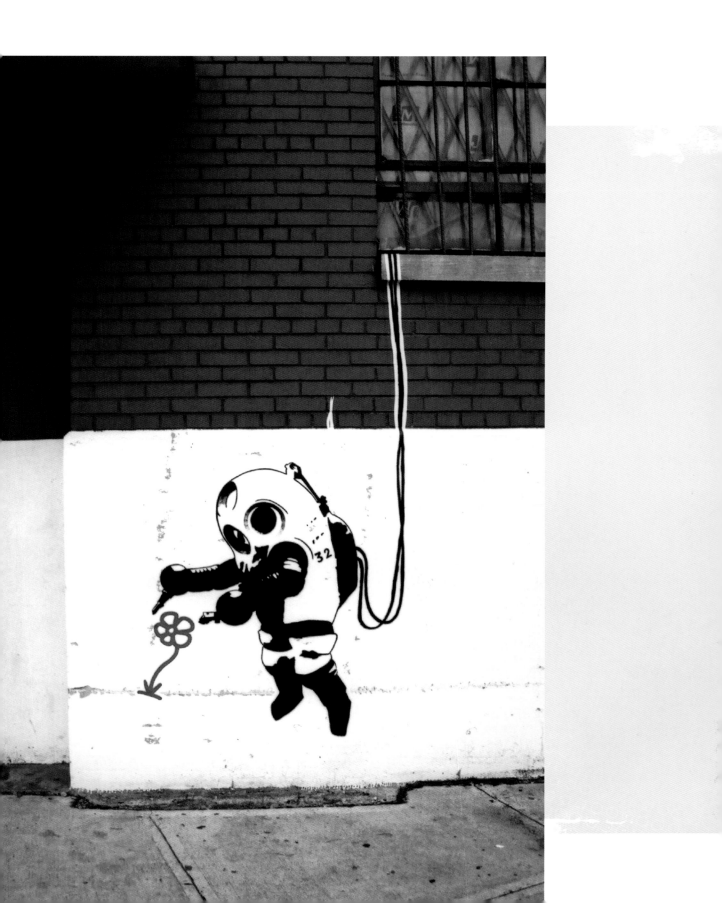

GouLD

Berlin, Germany

Gould's style is difficult to define as he continually strives to modify and adapt his innovative ideas with new techniques. He has made large-scale photocopies of his drawings and experimented with photography; in some works he photocopied pictures of cows, gave them wings, and pictured them flying through the streets of Berlin; in others, he displayed a range of moods, from thought-provoking to sad. In the poster jungle that has engulfed the city, it was his collages that particularly set him apart: large figures made from photocopies on coloured paper were cut out and then assembled; though human in form, they generally had exaggerated facial features or an animal's head. He has recently been using the screen-printing technique, but even in this established field continues to innovate with his fresh graphic twist. His commitment to the scene is indisputable, and he in turn is highly regarded and admired. Today, whether organizing exhibitions or coordinating *The Wallstreet Journal*, he remains the driving force behind many Berlin projects.

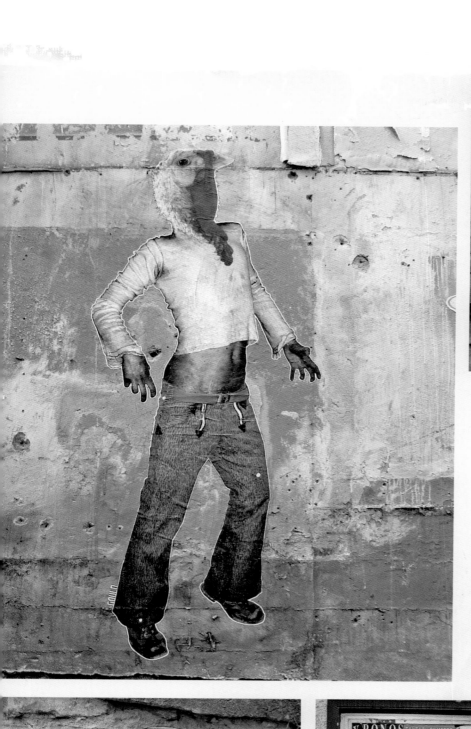
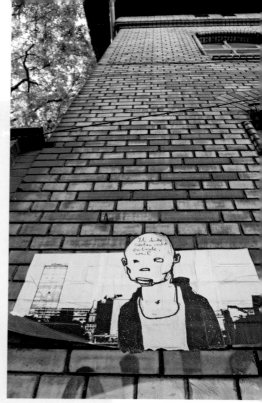
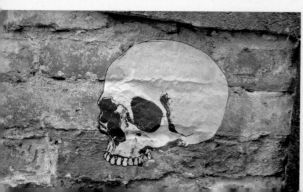
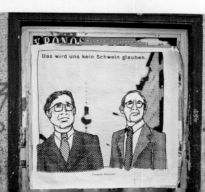
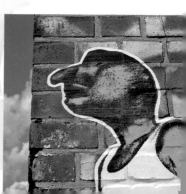

BLeK Le RaT

Paris, France

A comic title inspired his name – his stencil graffiti, a whole generation. Some twenty-five years ago stencilled black rats were spotted running along the walls of Paris; they were joined a couple of years later by life-size human figures. The public were outraged, although some home owners now hold sacred those pieces that have survived the buff. As the flood of tags spread, graffiti laws became more aggressive. When Blek Le Rat got into trouble with the authorities in 1991, he looked for a less risky medium. From then on, Blek transformed the streets of Paris, Naples, Leipzig, Morocco and Toledo with cut-out portraits of his family in poster format. However, the screen-printing technique alone was not enough to satisfy him, and in 2001 he reverted to his preferred medium: the stencil. Today, he sticks posters of his stencils around the world.

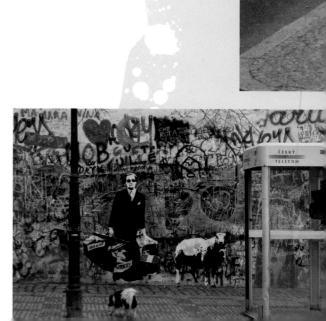

Above

San Francisco, USA

Above's work isn't always the easiest to spot. Not only is his name a concept – an upward-pointing wooden arrow – but he sticks his work high up in prominent positions overlooking the street; generally the diversely decorated arrows fall out of your normal line of vision and you have to look up or tilt your head back to see them. Above came up with the arrow idea several years ago, drawing his inspiration from the universal language of logos. Onlookers may interpret it freely for themselves, he says.

Thousands of people from a huge variety of different places have been able to make up their own minds, as Above doesn't just travel a lot – travelling is his life. While living in Paris, in 2002, he alone attached more than 400 wooden arrows to walls around the city. He must have lost count of the number of arrows he has left in all the countries he has been to!

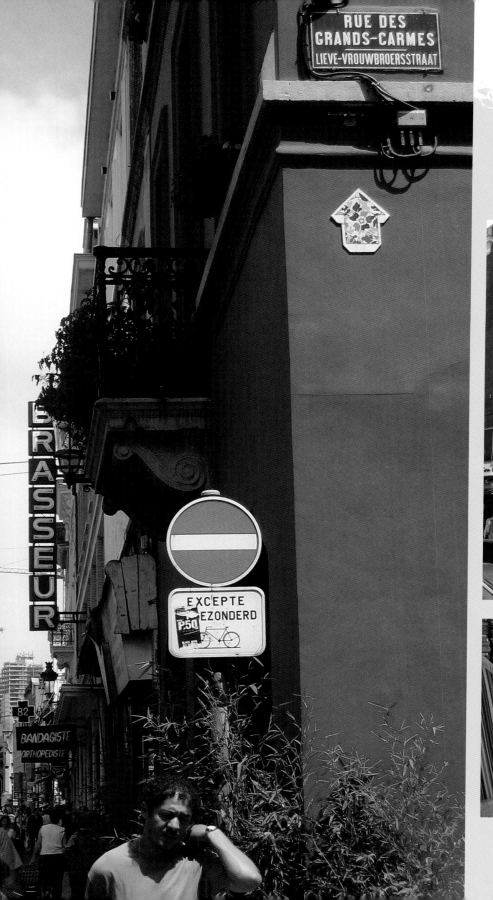

kArL ToOn

Halle, Germany

Karl is a friendly little boy who was created to reflect everything that the people of Halle experience, think and feel. Just like them, he waits at the stop for the next bus, dreams of having a girlfriend on Valentine's Day, and celebrates Christmas with a tree, presents and spangly decorations. Like them, he also loves to travel. He has been lucky enough to have this last wish granted owing to the support of a large number of friends who have helped to bring him to life and willingly made room for him in their cases. He has already been on adventures around four continents and continues to surprise people back home too by appearing in places they would never expect to see him. Recently, he was spotted in Halle carrying balloons at the Christmas market. Who knows where he'll pop up next....

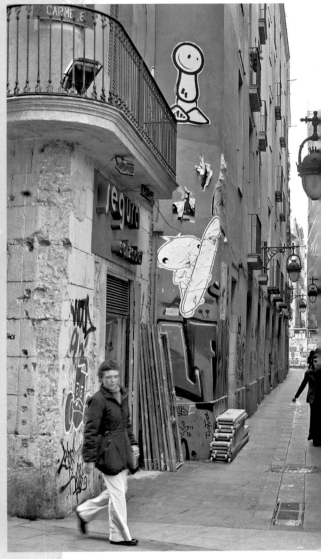

DaN WiTz

New York City, USA

Dan Witz's optical illusions are so realistic
they can stop you in your tracks. He uses a
painstaking process that can take hours,
printing photos on to vinyl sticker paper
which he then paints over in thin coatings
until he gets the right effect. The small
cut-outs are then skilfully placed in desolate
places that give his work new dimensions: on
a refuse bin, for example, a solitary boat looks
like it's floating on a nocturnal sea; abstract,
three-dimensional objects positioned over
a graffiti piece to give an amazing sense of
depth; or a skateboarder on a door, swerving
between tags.

After 9/11 Witz captured the emotions of
New Yorkers by putting up shrines on lamp
posts. Nobody could understand how he was
able to recreate shadows and flickering candle
light so realistically on dirty, tagged surfaces.
First he would select a lamp post and take
a picture of its base; he then printed the
full-size image on sticker paper and painted
the shrine on to it; the completed sticker was
placed in exactly the same spot on the original
lamp post. Everything we see on the base is
one huge sticker.

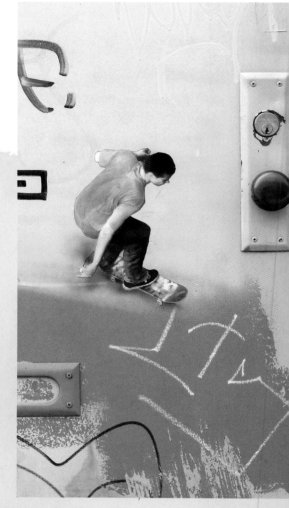

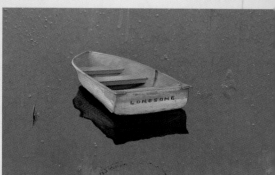

ToWeR

Berlin, Germany

Stickers and posters are generally understood by the general public as part of a widely accessible pictorial language. In the past Tower has stuck photos and figures in the street, but his passion lies with written type. Since 2001, he has played on the five letters of his name in a variety of different forms and locations, primarily in the German capital. Typography and logo design govern the works, which are always printed by Tower himself. In some months he has been known to produce over 1,000 stickers, using his own stamps or stencils, or creating the works freehand. He prefers sticking his posters to decrepit old walls, where they weather well and gradually start to look like they are from a bygone age.

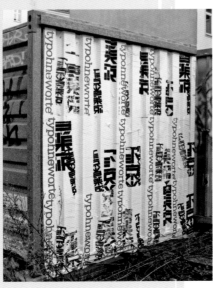

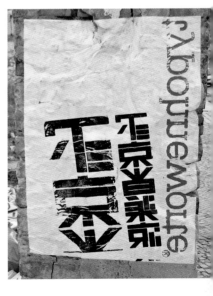

LiNDaS Ex

Berlin, Germany

If, in 2004, the city of Berlin had awarded a prize to its most lovelorn citizen, Lindas Ex would have won it. Through effective, hand-drawn posters, we also suffered the torment of a break-up. Fresh insights into the deepest thoughts of one unknown man cropped up at regular intervals. Only the name of Linda, his last love, offered a clue as to his identity. Neither the declarations of love nor her sudden fame softened Linda. Even local poster artists who had intervened did not manage to persuade Linda to go back to her ex. And then, just as a whole district was suffering, hoping and worrying, it emerged that Linda might never have existed. Some people still refuse to recognize that this scenario, which culminated in an exhibition, had been at the centre of tittle-tattle for almost two years. However, it seems we have heard the last of Linda.

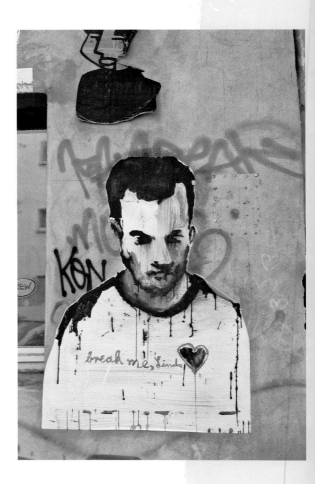

Opposite, clockwise from top left: 'My head in concrete since Linda left me'; 'Nikita, Gould, Robot, Pistazie, Tower, Gähn...and all the others. I need your help in looking for Linda. She doesn't answer her mobile'; 'Thinking about Linda is like swallowing hedgehogs'; 'I throw up without my Linda'

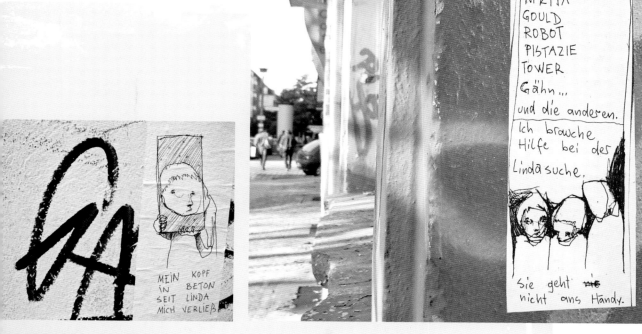

NIKITA
GOULD
ROBOT
PISTAZIE
TOWER
Gähn...
und die anderen.
Ich brauche
Hilfe bei der
Lindasuche.
Sie geht ~~die~~
nicht ans Handy.

MEIN KOPF
IN BETON
SEIT LINDA
MICH VERLIEß

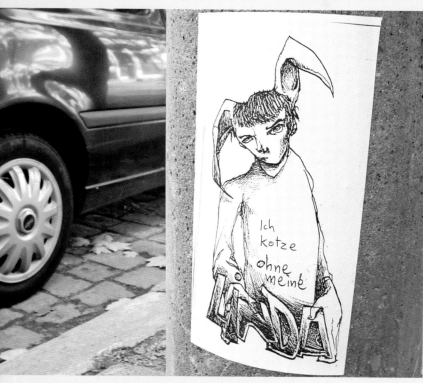

Ich
kotze
ohne
meine
LINDA

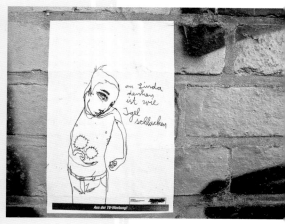

an linda
denken
ist wie
Igel
schlucken

Aus der TV-Werbung!

sWoOn

New York City, USA

Today's scene places a great deal of value on hand-crafted detail, but few artists invest as much time in their work as Swoon. It is not uncommon for one of her cut-outs to take two weeks to complete. She developed her complicated cutting technique in the early 2000s, working in the streets of New York. At that time she adorned walls with near life-size figures made from white paper. In contrast to the modern tendency to simplify production processes, Swoon's posters have become more complex and detailed. She prints the enormous sheets of paper with woodcuts or linocuts, and then elaborates elements with a brush and acrylic paint. The number of layers often depends on the motif itself. Often the amazing detail only hits you on closer inspection; complete street scenes can be made out within the bodies of the figures. The numerous perforations help the artworks to experience a metamorphosis with the city surfaces.

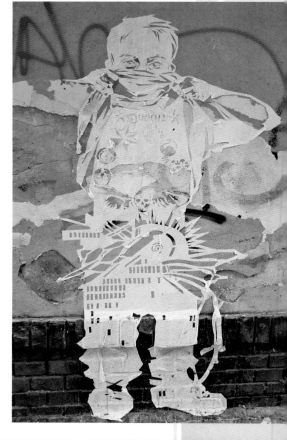

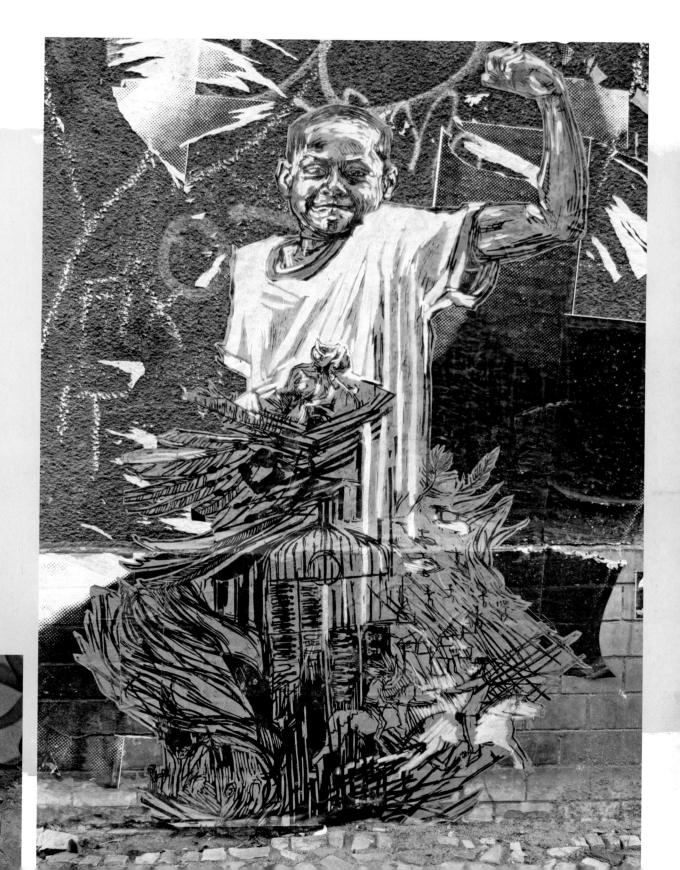

The London Police

Amsterdam, Netherlands

Innumerable creatures and fantasy characters grace our city surfaces today. However, only a few have achieved the same level of recognition and fame as the 'Lads' by The London Police. These friendly figures with multiple heads were originally created by Chaz for fun and first started to appear in Amsterdam in 1998. In 1999, Chaz was joined by Bob and, the following year, Garret. Members have since come and gone, and Chaz has often run the project by himself. Travel and exhibitions enable the group to distribute the black-and-white figures throughout the world—from Berlin via New York to Tokyo, they appear in new combinations, in lines and circles perfectly drawn by hand, on posters, stickers or wall drawings. They often bear numbers on their feet or bodies, but it is up to the passer-by to interpret them.

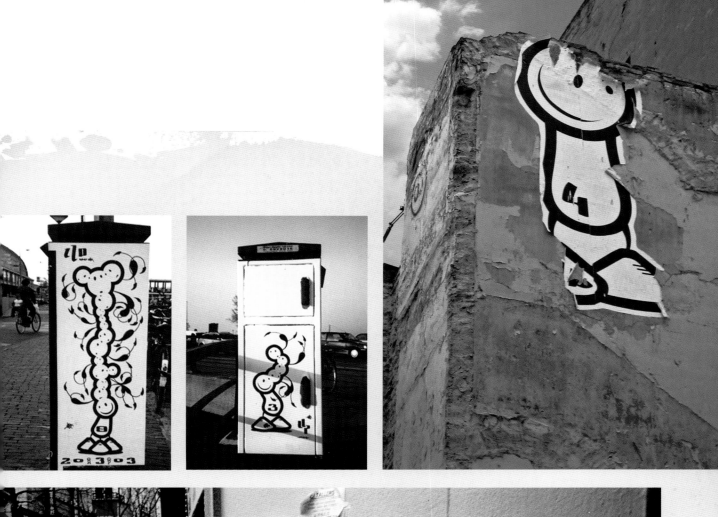
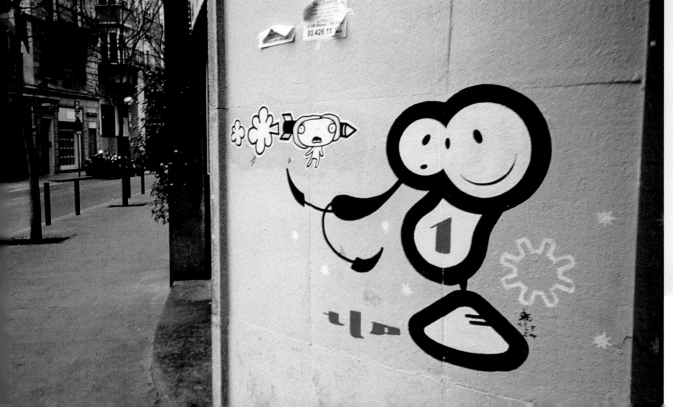

pash*

Prague, Czech Republic

Colourful figures have been making their presence felt in Prague for some time. They are stuck in unusual locations, often high up out of reach. Pash* lets his imagination run wild and leaves the results on bridges, windows, doors and walls, using a range of materials such as coloured foam and acrylic paint on paper. He puts a great deal of store on the handmade, unique elements in all his figures, which means he is very attached to them. Although fellow artists from around the world call on him time and again, Pash* prefers to stick his own works in his home city. That way, he can visit them every once in a while and see how they have changed as time, weather and passers-by leave their own touches day by day.

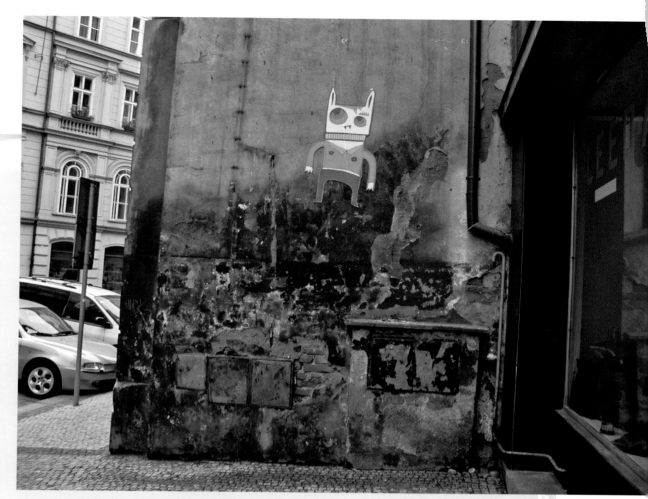

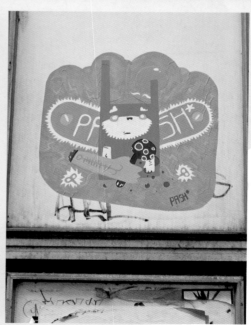

No LoGO

Dresden, Germany

Pixelated angels flying through pixelated clouds, pixelated rockets flying over pixelated skies, and pixelated men wearing pixelated suits: the square has become the mark of the man without a logo. Although he paints figures in the street, it's the computer images that stick in your mind. He was spraying his name for many years before he adopted stencil and screen-printing techniques; later, he created enormous pictures on walls with a brush and paint roller; now postal stickers have become a particular favourite. His creations can be found not only in several German towns, but also in France and Spain. The unrealistic, striking forms on walls, lamp posts or traffic signs are the most conspicuous. They play with our perception and our imagination, and to every person they mean something different.

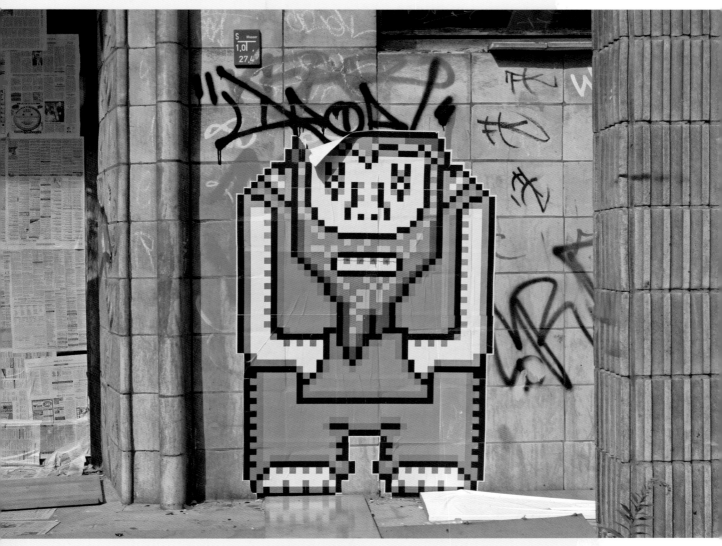

56 k

Hamburg, Germany

Many artists who choose the street as their canvas have their roots in the graffiti culture. 56K belongs to this group. On his first stickers he used a spraycan and stencil to write the message 'Graffiti loves you'. This slogan, which was meant in all seriousness, was soon copied on to numerous stickers and plastered all over Hamburg. The graphic black-and-white aesthetics of that time are still employed today. 56K tried out all sorts of image ideas on a computer, including humorous figures, road sweepers and knives. After making large-format copies of the images, he cuts them out and sticks them around the city. Every so often he also uses the formal language of traffic signage and attaches fake traffic signs to posts. In one of his most recent sticker projects he imitated the packaging of a well-known chewing gum brand, changing the label to 'Wasted spare time'.

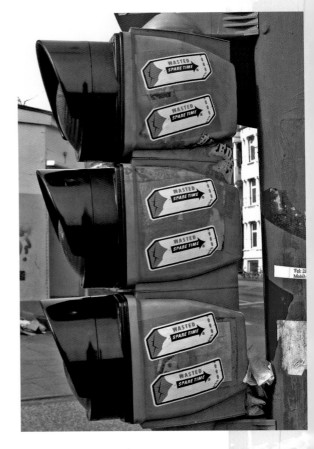

BLuEs BrOtHeRs

Leipzig, Germany

Inspired by a journey through Spain's cities and tired of classic graffiti aesthetics in the world's capitals, the Blues Brothers decided to redesign their local area with paper and paste. They started off small, with handmade stencils on postal stickers; soon they moved on to large-scale copies of their drawings and increasingly added colour. They have been producing large unique works with spraycan and brush on paper since 2003 and now, having abandoned computer graphics altogether for their art, only display one-offs. Motifs range from portraits and fantasy figures to totally abstract designs.

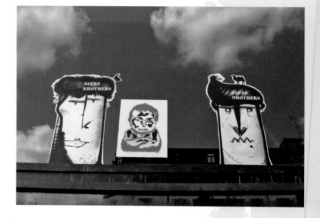

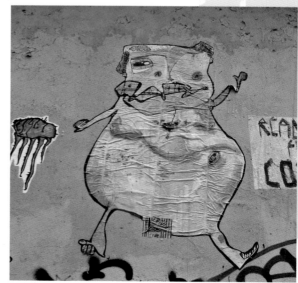

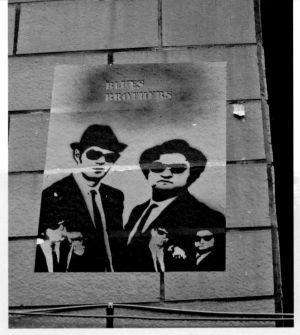

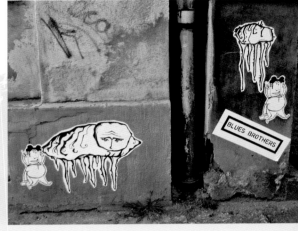

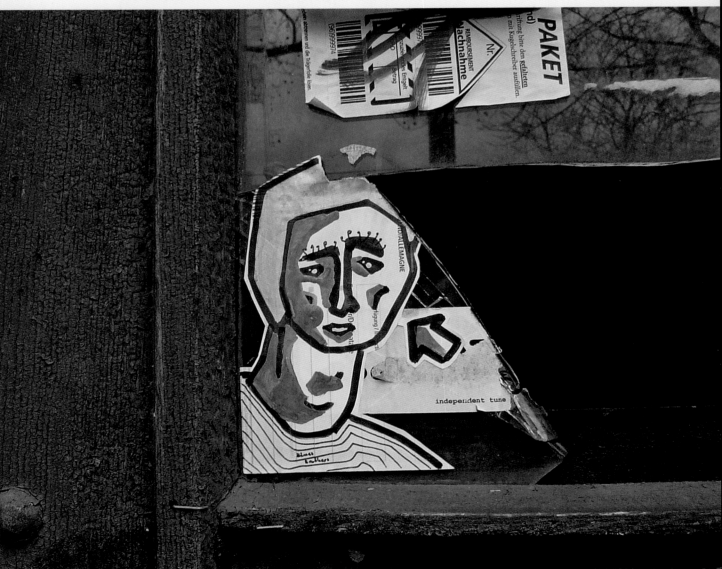

WK iNteRAcT

New York City, USA

Many adhesive artists work exclusively with black paint on a white background because it's more cost-effective, but this approach can make it even more difficult to stand out in the dense urban jungle of street and graffiti art. French artist WK interact manages to distinguish himself from the masses remarkably well. In his adoptive home city of New York, it is the energy of the street and the fast pace of life that particularly fascinate him. He captures this energy in his posters and wall drawings through the likes of cyclists, skateboarders and fight scenes. The figures he depicts often appear notably active, a characteristic that is often enhanced by the use of motion lines. They never fail to make an impact on onlookers, whether they appear on a wall, a canvas or a car.

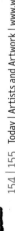

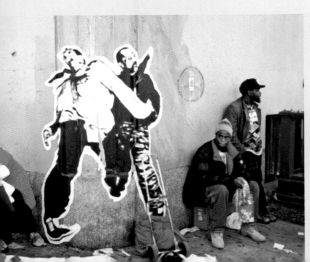
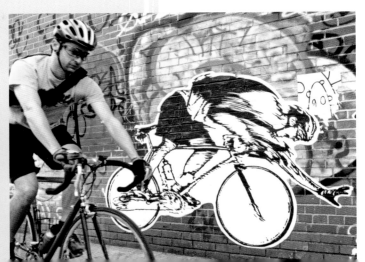

PoCh

Rennes, France

Poch has been a stencil artist since the late 1980s. At that time, he spray-painted directly on walls, but the combination of his current style of large, flat shapes and the fragility of the stencil medium makes it virtually impossible for him to spray-paint on stonework. Moreover, certain surfaces soak up the colours, which then come out too strong. For this reason Poch has preferred using paper since 1998. French and English punk and rock culture is his greatest inspiration. Influenced by the graphic aesthetics of these music trends, he made most of his posters in black and white, although over the past few years he has increasingly been branching out into colour. He does not see his posters as street art in the modern sense of the word, but as a continuation of graffiti and stencil culture.

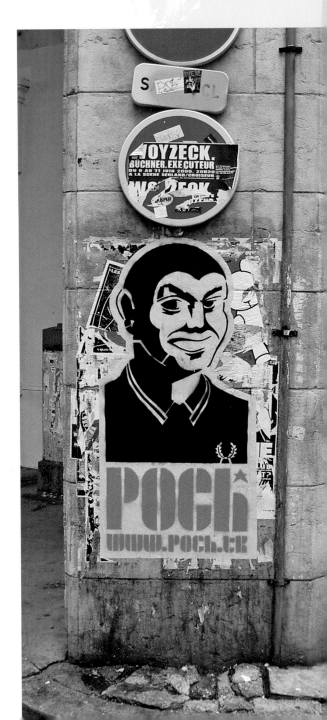

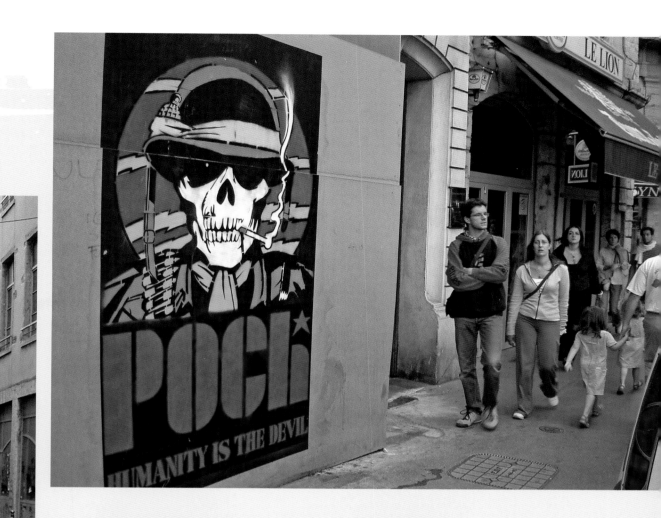
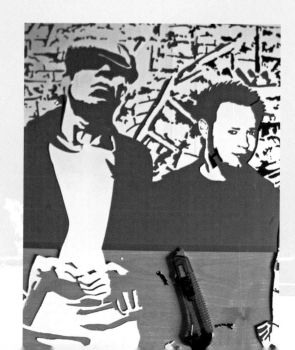

meLLo

Brasília, Brazil

Mello has been working in the streets of São Paulo and Brasília for more than ten years. When he was a child he was inspired by the authentic Brazilian graffiti known as *pichação*. Today he uses spray-paint, applying it either directly to the wall or on stencilled paper cut-outs. He draws on many creative forms of expression: photography, illustration, typography and Web design. He also loves dilapidated old buildings, which he brings back to life through his pictures. He fights to grab the public's attention with a rich variety of artworks. However, this is becoming increasingly difficult, he says, owing to widespread ignorance among the population, which he primarily blames on trash TV. In response, he has been producing works that are critical of society. His representations of the homeless, which he posted in his home city, were particularly haunting.

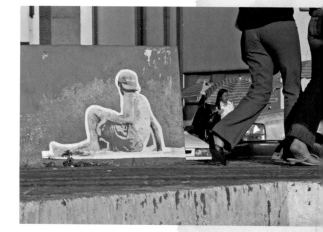

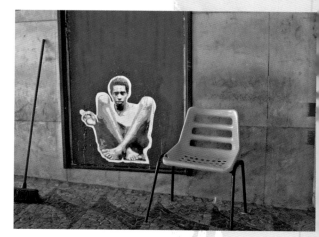

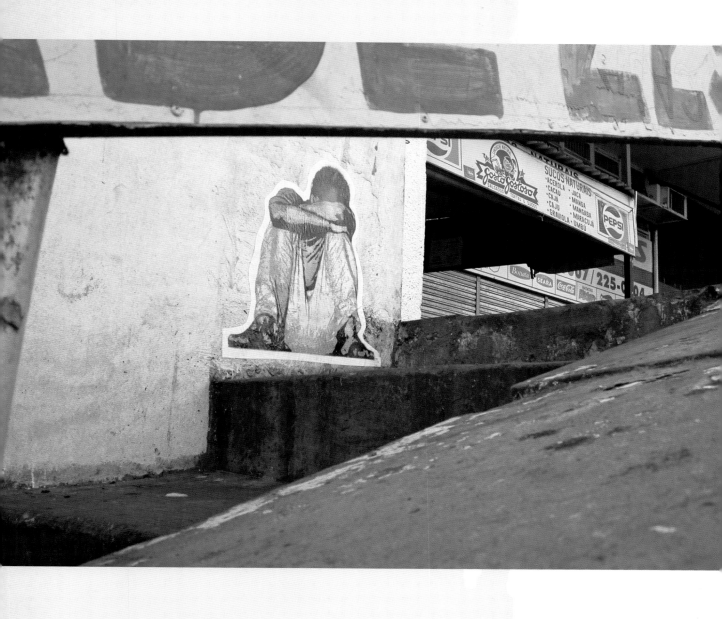

iNvAdeR

Paris, France

When *Space Invaders* was launched in 1978, it was one of the first video games to hit the market. Though simple by modern-day gaming standards, this struggle to overcome an alien invasion gripped youngsters and adults alike.

In recent years the extraterrestrial aggressors have been making another appearance, taking to streets around the world. They first invaded Paris in 1998 and have since appeared in more than thirty towns, watching our every step from every conceivable surface. They lurk in entrances, observe us from bridges and walls, track us going down into the subway and have even been spotted rubbing shoulders with the stars on Hollywood's Walk of Fame.

Invader uses colourful ceramic squares to create the creatures, transforming computer pixels into durable, solid mosaics that are attached to surfaces with cement. Each mosaic contains 120 squares on average. Resolute on taking up permanent residence, it looks like the invaders are here to stay.

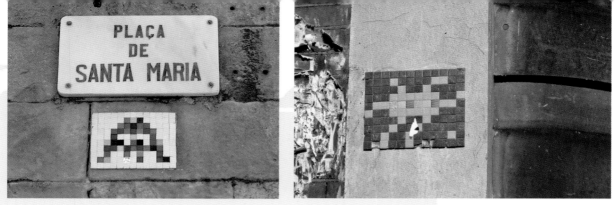

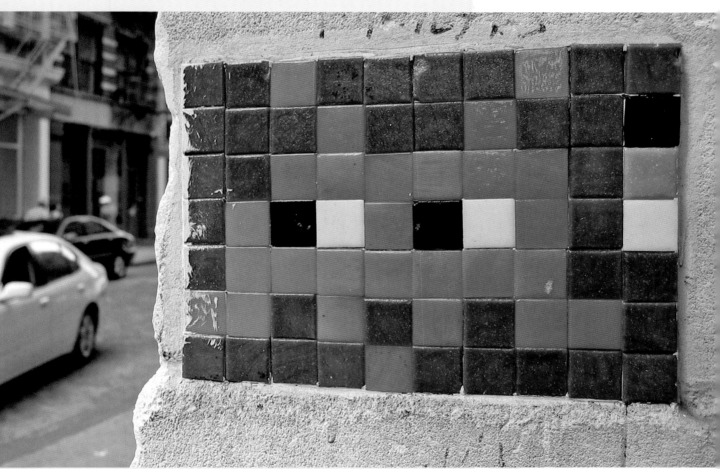

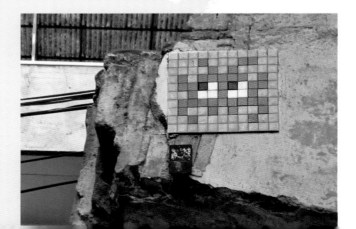

ShEpArd FAiRey

Los Angeles, USA

Obey the Giant! Shepard Fairey's propagandistic posters have been shouting commands at us for a long time now, and the scene has taken note. Every street artist is familiar with the clear graphics, and most have at some point or other used the constant repetition of a motif in their work. However, to date, nobody has come close to matching the size and extent of the wrestler portrait, be that spray-painted stencil graffiti, huge posters on water tanks, walls and hoardings, or small stickers on traffic lights and lamp posts. By being extremely active, Fairey impressively showed that an innovative motif can arouse more curiosity and renown than any transparent advertising campaign.

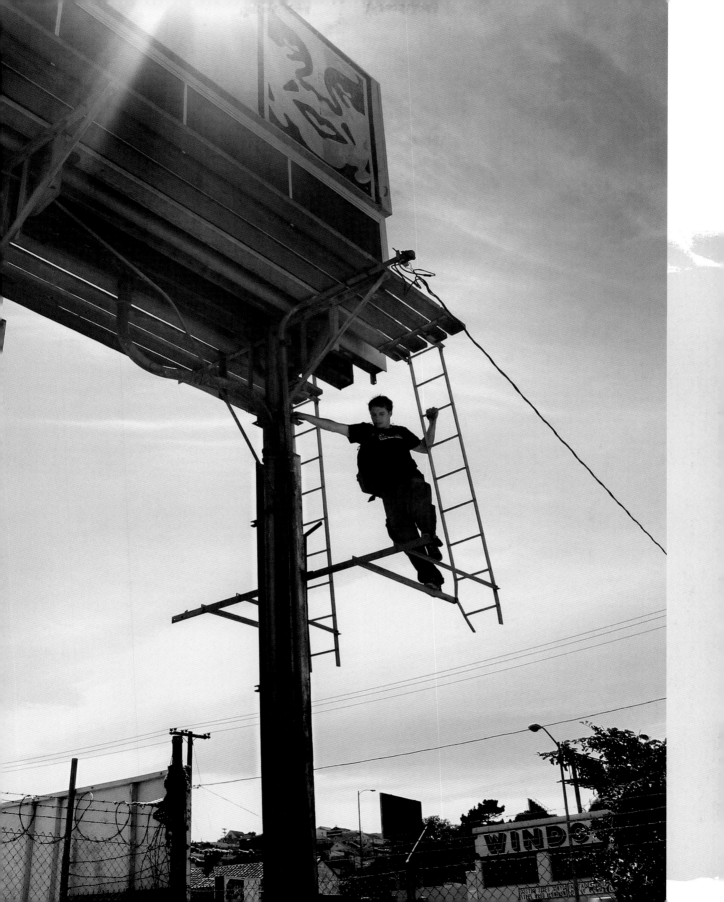

iNFLUENZA

Rotterdam, Netherlands

Influenza is always discovering new ways to enter public space. In the mid-1990s he realized that stickers are a simple and cheap means of working in the street and has since used this medium as a vehicle for numerous ideas. When fly stickers were introduced in urinals in the Netherlands, Influenza used this motif to expose manipulation, and the fly became his symbol. He often sticks it on poor poster advertising and, in his words, 'next to good interventions by fellow pirate contributors'. In another sticker project, he plastered the 15,000 most popular English words in advertising around countries where no English is spoken. In other campaigns, he made the texts of advertising posters unrecognizable so that they lost their meaning, and he initiated a worldwide group game to reconquer the streets with the help of small, spray-painted soldiers.

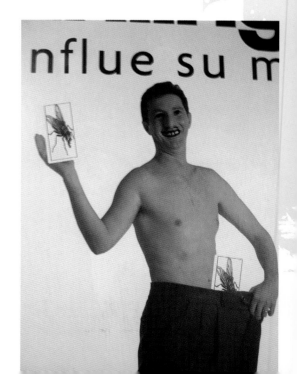

Yok

Perth, Australia

Many artists find inspiration on their travels. Yok was so impressed by what he saw in Melbourne, Europe and particularly Africa that he decided to stick his own drawings on the walls of his home city. For many years he had been fascinated by medieval gargoyles, whose grotesque forms were thought to scare off evil spirits. The gargoyle's protective role resonates throughout his work. Often he adorns his black-and-white figures with wings, like guardian angels, or embellishes their bodies with stories, which he relates through a combination of characters, faces and words. Yok likes the thrill of seeing passers-by turn in astonishment and try to work out the meaning and purpose of his stickers and posters, which appear in a wide variety of different sizes and formats.

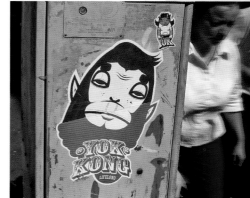

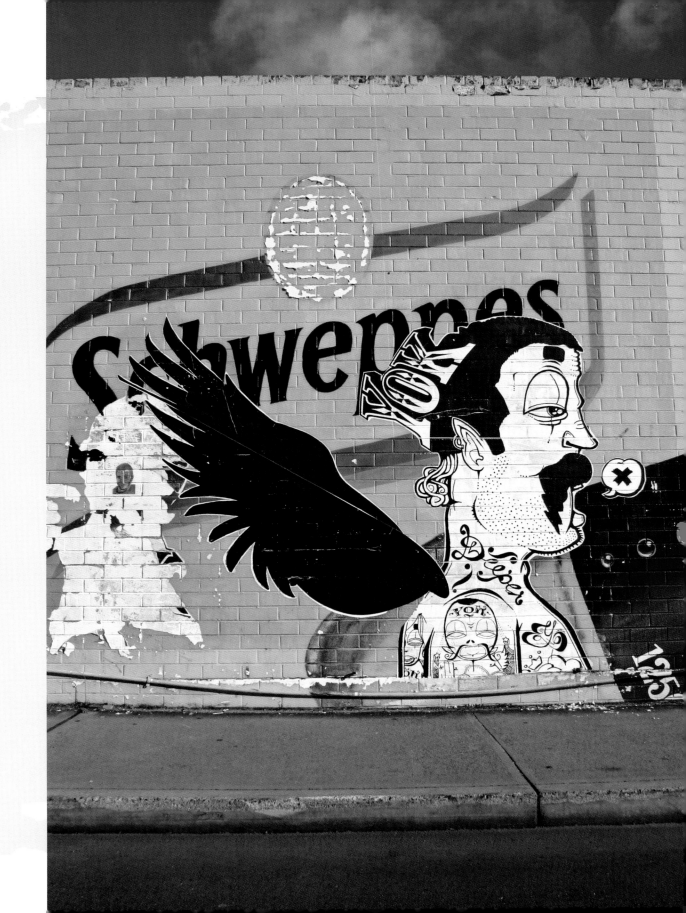

RROW

Chapter Three

Exhibitions

How will the scene develop over the next few years? Is the number of artists growing or is interest waning? Is the quality of work improving or declining? How will the population and authorities react to works of art in the future? Will this art make it into museums? Or will it remain confined to the streets?

Despite the international and well-informed nature of the scene — a networked community that nurtures continual contact over the Internet and through exhibitions — there is no consensus of opinion among artists. In order to cast an eye to the future, it is important to consider every aspect of current developments. ➡

FUCK YOUR CREW, Berlin

FUCK YOUR CREW, NoLogo, Berlin

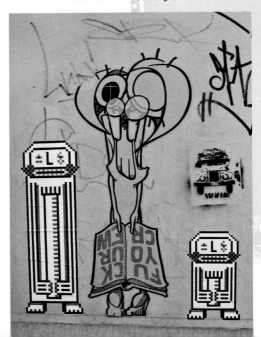

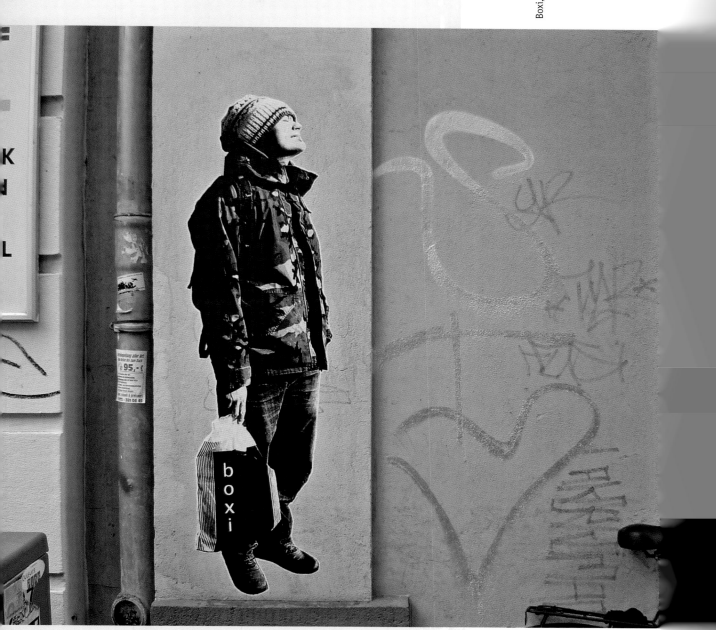

For many people, the engaging community atmosphere is an important reason for continuing to be active, as Lepos confirms: 'Being into graffiti or street art is great because it gives you something to do wherever you go and helps you meet all sorts of good people.' It's a viewpoint shared by Thundercut: 'The scene is fantastic. It attracts enthusiastic and curious people.'

Exhibitions in galleries and museums could certainly have an influence. Some artists could, by virtue of their success, transfer to galleries, turning their back on the street. However, it is also possible that graffiti and street art could trigger changes in the gallery world, narrowing the sharp divide between the art and its environment

by introducing thoughtful, effective alternatives. For some time now, people have been applying different ideas in an attempt to master the difficult balancing act between street art and the framed artwork. Indeed, frames are rarely used in exhibitions of graffiti and street art. The works of art are stuck directly on to the wall, in a deliberately chaotic way, to avoid the geometrical order of the traditional gallery space. Often street signs are integrated into the scene, or the walls themselves are painted with apt motifs. Swoon created a whole city for her exhibition in the Deitch Gallery, New York, using this cutting-edge approach. Her paper works of art were stuck or hung between imaginary walls and doors. ➡

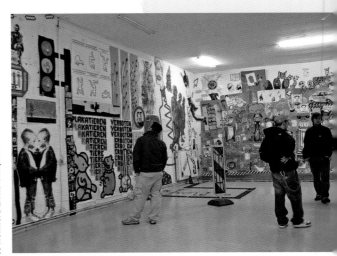

'Road to Nowhere Exhibition', Berlin

'Road to Nowhere Exhibition', Berlin

Swoon, Deitch Gallery, New York City

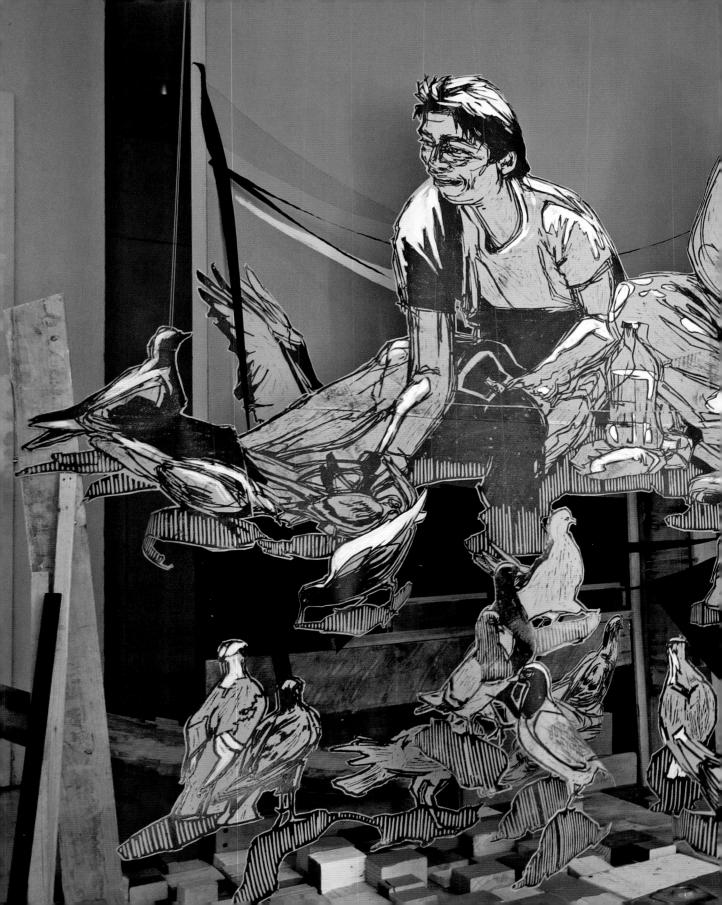

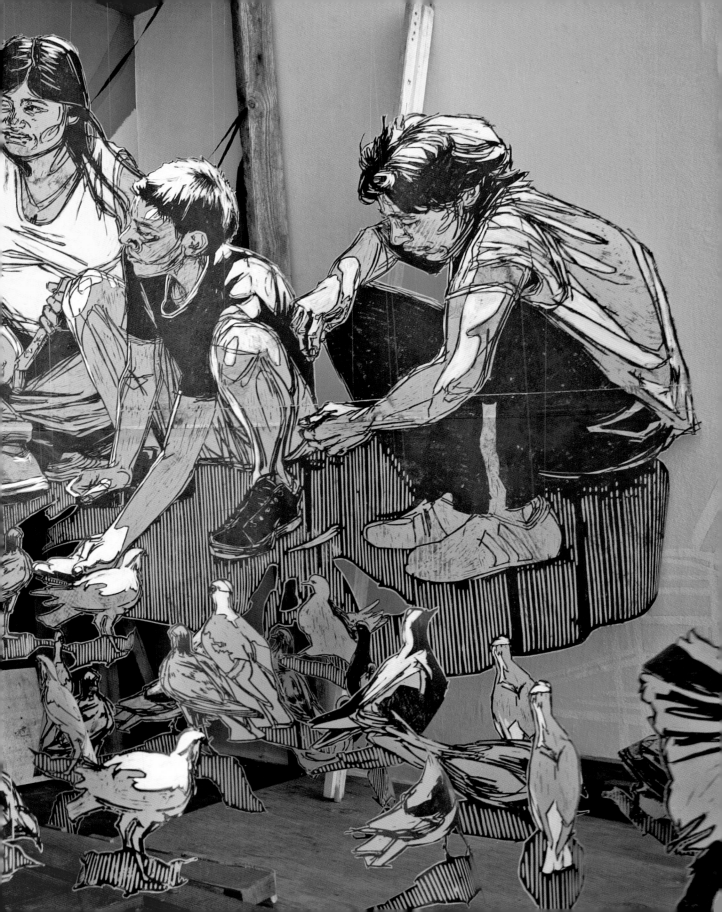

Gould, Berlin

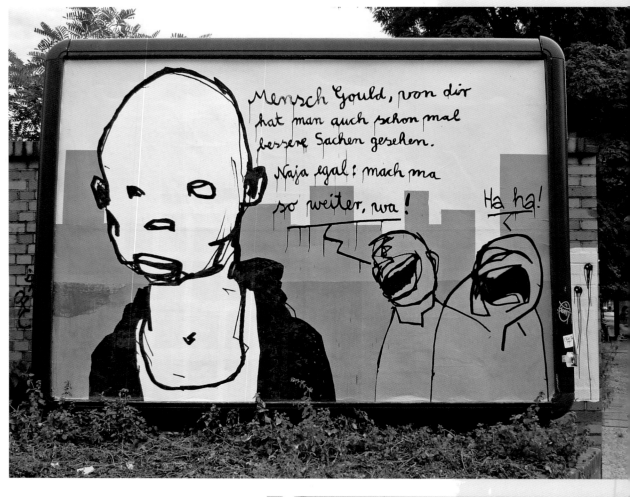

Invader Exhibition, Paris, Galerie Patricia Dorfmann

The scene could also improve the general public's appreciation of art through events. Official exhibitions of street art have already been taking place in the open air. Within the framework of 'Camp Kleister' in Berlin, for example, the organizers hired billboards for a number of (mainly local) artists to display posters of their work. 'Backjumps', a street art exhibition that has been very successful, particularly in the Berlin scene, took place in the summer of 2005 for the second year. Not only did the team organize exhibitions, but they also arranged city tours and workshops that were warmly received by the community. A similar concept took place in Sweden under the name 'Everwanting Streets'.

The 'Finders Keepers' events are particularly popular as they show live art from the street in an authentic way. Artists create innovative artworks on found material and waste and then exhibit the imaginative results in a show that lasts for one night only. At the end of the event, the artworks are handed out to visitors for free. 'Finders Keepers' has already taken place in several cities.

Karl Toon, 'Camp Kleister', Berlin

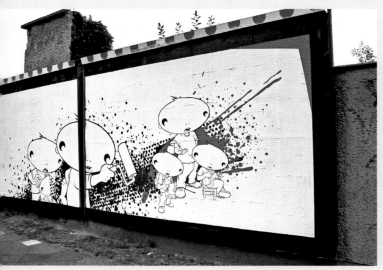

Art and Commerce

External awareness of new forms of urban expression, and their inevitable commercialization, is already impacting the street art scene and only looks set to intensify in years to come. Ad agencies have long recognized the potential in harnessing authentic aspects of street culture to create cutting-edge campaigns and are tapping into adhesive art. In commercials on MTV, for example, it is not uncommon to see black-and-white, cut-out figures bouncing merrily across the screen. Coca-Cola has also drawn on street aesthetics in its extensive advertising repertoire, including splatters of black on a white background coupled with matchstick figures. This is also true of music videos – the smiley face sticker in Bon Jovi's 'Have a Nice Day', for example, or the stencilled figures that come to life in Starsailor's 'Four to the Floor'. Within this framework, some exceptionally good designs have undoubtedly been created. Indeed, many artists in the scene earn their living from commissions. It takes just a small step to turn art that has been freely developed for the street into commercial work. On the other hand, many artists also decline lucrative offers or shun industries such as advertising, which are widely associated with 'selling out'.

Some artists also strive to turn their love for this art into a profession, so that they can in future devote themselves to their work 24/7. Many paint or sell canvases or print T-shirts. Others collaborate with toy companies to develop plastic figures and puppets that originated in the street. Many of the toys have already achieved collector status. These facets of marketing often lead to debates within the scene, particularly as there are a fair number of artists who are very critical of this development and refuse to make any kind of financial profit from their art.

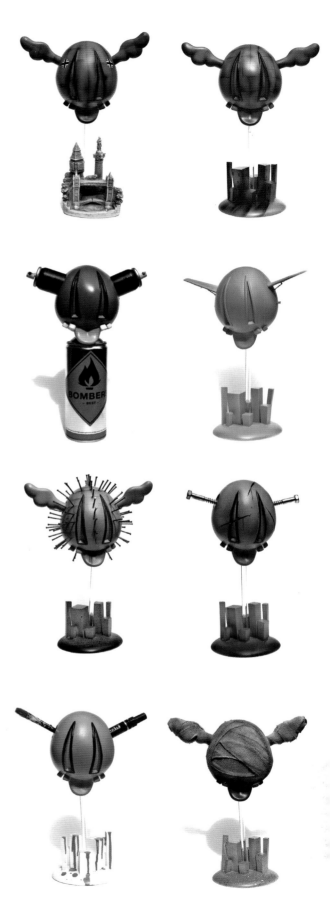

All by D*Face

A Look to the Future

We can only speculate about the future, but a few aspects of the scene are already changing so markedly that we can make fairly accurate predictions. One thing is certain: the police and authorities are getting tougher with illegal adhesive art, and this looks set to continue. In New York, for example, adhesive art is already much less common than it was three years ago, clearly stifled by the strong police presence. Some artists have spent several days in prison and have been hit with high fines. Since the summer of 2005, illegal bill-sticking has been part of anti-graffiti law in Germany, and within just a few weeks of this change the number of active artists and artworks in the streets dramatically declined. The same has happened in France, the Netherlands, the UK and Spain. In short, laws are being tightened in almost every country in the developed world. It only remains to be seen how severely these laws are enforced and the number of cases that lead to prosecution. Paper can, after all, be easily removed with warm water.

At this crucial time it is the artists who will have the last word. One glimmer of hope can be gleaned from the story so far: street art has been growing continually since its very beginnings and has always found new ways to elude (or ignore) the law. Our city streets will certainly change in future. Let's wait and see how they evolve and what new materials emerge. The following few pages contain thoughts and insights from leaders in the adhesive art field. ➡

Thundercut, New York City

Lolo, Barcelona

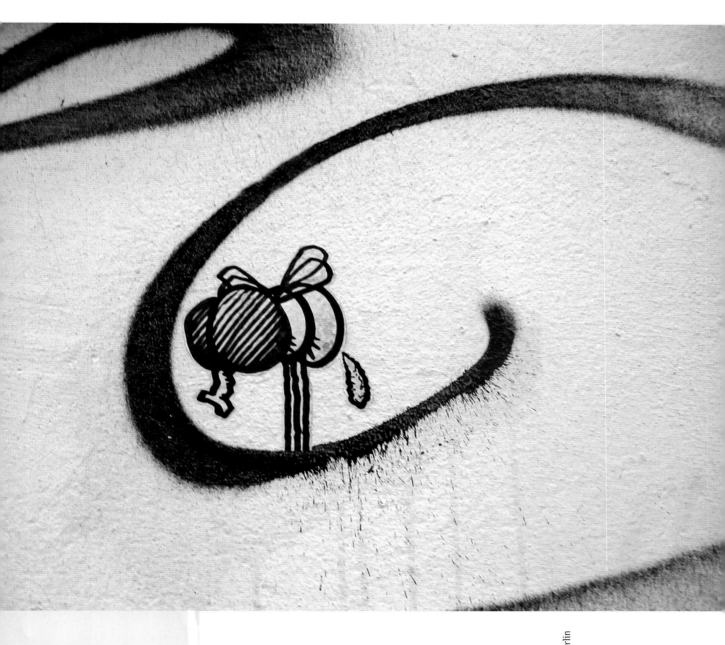

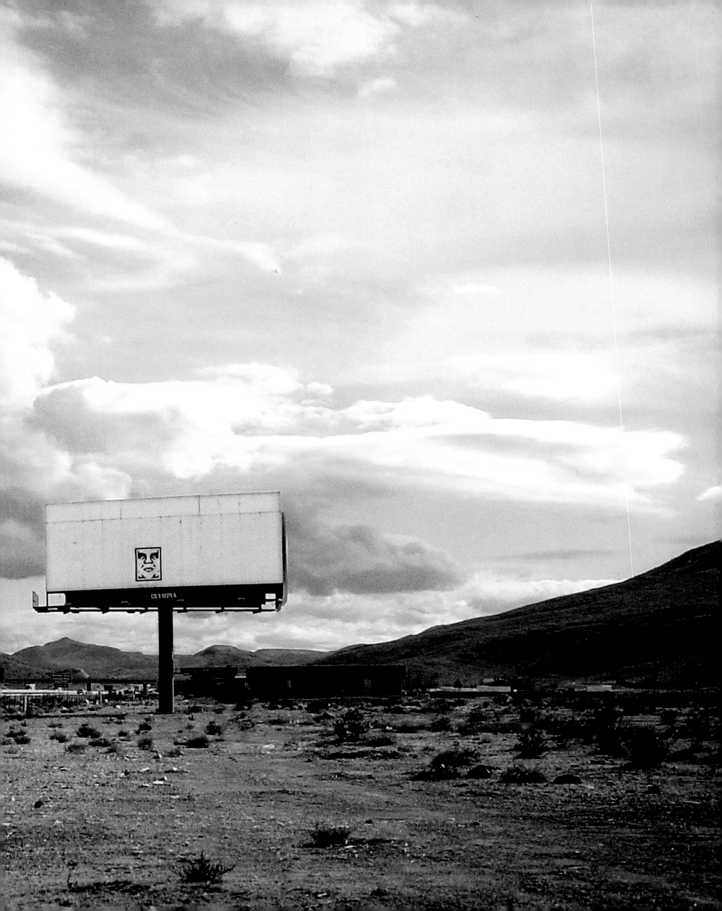

'I agree with Dan Witz's statement that the whole issue will burst like a bubble. Street art will continue, but public interest will decline.' Flower Guy

'Many people used to make stencil stickers but now get their stickers printed professionally. Perhaps having posters printed will also go down the same path.' Tower

'I believe street art will use more media and materials, more 3-D stuff. I am also worried that it will get *too* popular and that it will be used in advertisements etc. But I also believe that it will be more respected here and that people won't think that we're vandals.' Pash*

'I think people are going to try to be more creative by using new materials and making new things.' Invader

'I don't think that street art is as good today as it was five years ago. The Internet has made it too easy. Most people lack the aggression that distinguished many of the old graffiti artists.' Marc from Wooster Collective

'I think that the scene will become smaller as everybody can do it. You don't need to be a hardcore graffiti artist. Besides, there have already been so many ideas. It will become more and more difficult to do something original.' Chaz of The London Police

Hannibal Vector, Berlin

Nomad, Berlin

'Urban art will become corrupted by money, fake militants will appear, and the art will cease being as authentic, and it will be driven by commercial interests. This unselfish feeling of making art will become rare, other manifestations will appear, unimaginable things will happen.' Mello

'There will be a mixture of futures: more rubbish designs like toys and other commercial garbage; for some individuals, a gradual move towards the contemporary art field and business like international art fairs; the streets will be cleared and then covered again; there will be more collaboration with video and film and graffiti and design and architecture and other forms of commerce. Hopefully, the street art scene will find its way to becoming a mature form of expression.' Influenza

'As in the field of graffiti, it will become more and more difficult to do anything.' Blues Brothers

'It will simply run on, becoming larger and smaller. In six months, perhaps hardly anyone will show any interest. And people who have been engaged in these activities for fifteen years or more, like Dan Witz or perhaps even me, will simply carry on, as they are doing it out of a certain fascination, not on account of a trend.' Swoon

Red Ink, Dresden

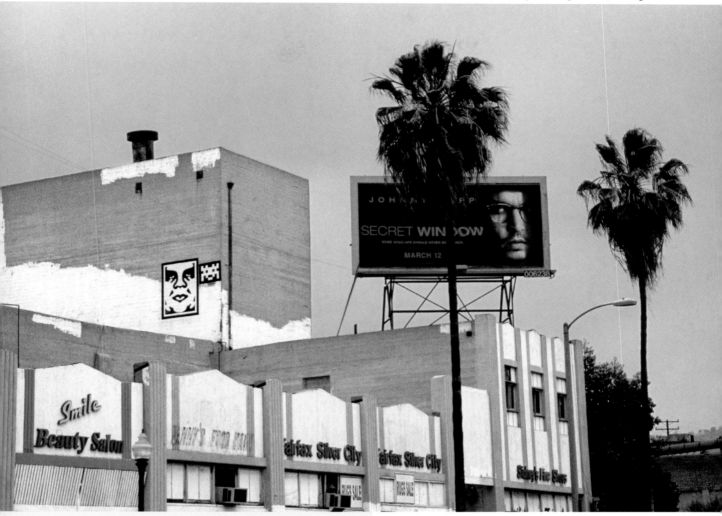

Shepard Fairey, Invader, Los Angeles

Mark, Zipper, Prague

Aem, Berlin

Lepos, New York City

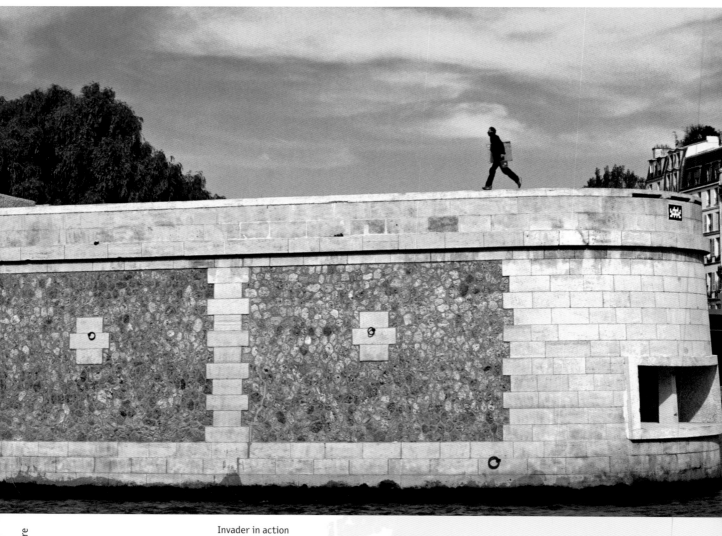

Invader in action

'I think that urban art has only just begun, although it has existed for forty years. Traditional art circles have completely fizzled out and do not offer artists real opportunities to express themselves. Urban art is the ideal means to express one's ideas and passion totally freely. Urban art is freedom par excellence, despite bloody repressions employed by the authorities in all the Lord's countries.' Blek Le Rat

'If you had asked back in the 1970s how graffiti would proceed, perhaps it would not have been possible to predict. I believe that we have got beyond the stage of a mayfly.' Gould

FUCK YOUR CREW, Berlin

FUCK YOUR CREW, Lindas Ex, Berlin

Websites

www.woostercollective.com
www.ekosystem.org
www.stickit.nl
www.km4042.de
www.backjumps.com
www.barcelonastreetart.net
www.graffiti.org
www.billboardliberation.org

Acknowledgments

Translation by Edward Gamlin.

Thanks to all artists and photographers who contributed worldwide. Special thanks to all those people who have helped and inspired along the way.

Thanks to: Marco Prosch, my family, Reno Rössel, Matthias Göbel, Stratege, Been3, Slide, Michaela Arnold, MK, Shepard Fairey, Invader, NoLogo, *G*, Lepos, Thundercut, D*Face, Bild, Michael De Feo, Gould, Blek Le Rat, Sybille Metze-Prou, Above, Karl Toon, Dan Witz, Tower, Möe, Lindas Ex, Swoon, The London Police, Pash*, Mark, NoLogo, Ghostpatrol, 56K, Blues Brothers, WK interact, Poch, Mello, Influenza, Yok, Dalek, Lady Pink, Crash, Kel, Pin 2011, Video, Nadine, Mogi, Mr Robot, Change, Akor, Dirdy Dirk, Beat, Mikey, Andrew Borromey, Andreas Göx, Michael Lippold, Lolo, Marc and Sara from Wooster Collective, TV-Boy, Meat Love, Alexandra Lulla, Foxy Lady, Shiro, Brett, Chas

Picture Credits L = Left, R = Right, T = Top, B = Bottom, C = Centre